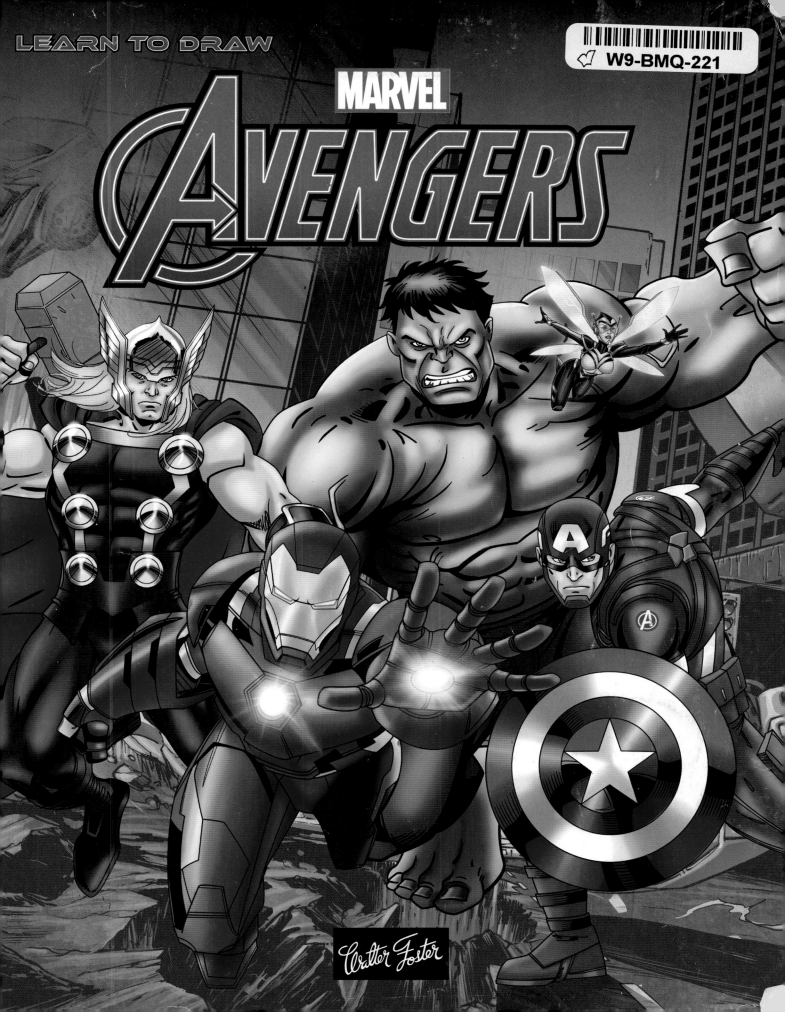

Character art by Cory Hamscher.
Photographs on pages 4-5 © 2007 Shutterstock, text on pages 4-5
© 2013 Bob Berry and Jeannie Lee, artwork and text on page 6 © Walter Foster Publishing,
and artwork and text on pages 8-9 © 2007 Debra Kauffman Yaun.

First Published in 2018 by Walter Foster Publishing, an imprint of The Quarto Group.
6 Orchard Road, Suite 100, Lake Forest, CA 92630, USA.

ISBN: 978-1-63322-512-1

Printed in China
10 9 8 7 6 5 4 3 2 1

MIX
Paper from
responsible sources
FSC
www.fsc.org
FSC® C101537

TABLE OF CONTENTS

TOOLS & MATERIALS

PAPER

Sketch pads and inexpensive printer paper are great for sketching and working out your ideas. Tracing paper can be useful for creating a clean version of a sketch using a light box. Just be sure to use quality tracing paper that is sturdy enough to handle erasing and coloring. Cardstock is sturdier than thinner printer paper, which makes it ideal for drawing repeatedly or for heavy-duty artwork. You may also want to have illustration board on hand.

PENCILS

Pencil lead, or graphite, varies in darkness and hardness. H pencils have harder graphite, which marks paper more lightly, while B pencils have softer graphite, which makes darker marks. A good pencil for sketching is an H or HB, but you can also use a regular #2 pencil.

COLORED PENCILS

Colored pencils layer over each other easily. They come in wax-based, oil-based, and water-soluble versions. Oil-based pencils complement wax-based pencils nicely. Water-soluble pencils react to water in a manner similar to watercolor. In addition to creating finished art, colored pencils are useful for enhancing small details.

ART MARKERS

Alcohol-based art markers are perfect for adding bold, vibrant color to your artwork. They are great for shading and laying down large areas of color. Markers and colored pencils can be used in combination with paint to enhance and accent your drawings.

ERASERS

Vinyl and kneaded erasers are both good to have on hand. A vinyl eraser is white and rubbery and gentler on paper than a pink eraser. A kneaded eraser is like putty. It can be molded into shapes to erase small areas. You can also use it to lift graphite off paper to lighten artwork.

PAINT

Have fun exploring acrylic and watercolor paint. Watercolor paints are available in cakes, pans, and tubes. Tube paints are fresher, and the colors are brighter. Acrylic paint dries quickly, so keep a spray bottle of water close to help keep the paint on your palette fresh. It's a good idea to have two jars of water when you paint: one for diluting your paints and one for rinsing your brushes.

DRAWING BASICS

Drawing consists of three elements: line, shape, and form. The shape of the object can be described with simple one-dimensional lines. The three-dimensional version of the shape is known as the object's "form." In pencil drawing, variations in *value* the (relative lightness or darkness of black or a color) describe form, giving an object the illusion of depth.

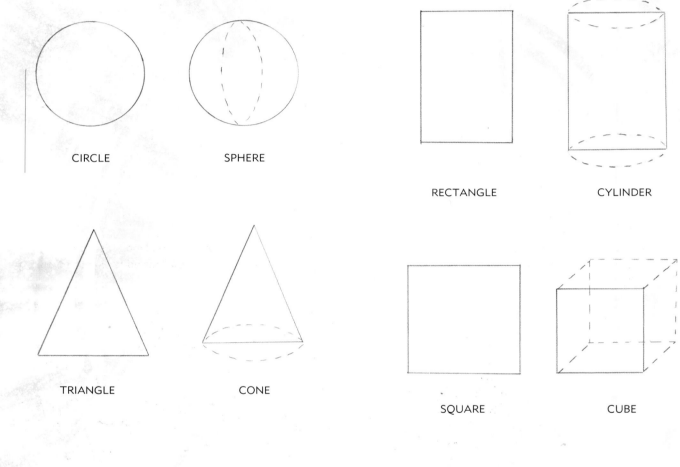

CIRCLE SPHERE RECTANGLE CYLINDER

TRIANGLE CONE SQUARE CUBE

ADDING VALUE TO CREATE FORM

A shape can be further defined by showing how light hits the object to create highlights and shadows. First note from which direction the source of light is coming. In this example, the light source is shining from the upper right. Then add the shadows accordingly. The *core shadow* is the darkest area on the object and is opposite the light source. The *cast shadow* is what is thrown onto a nearby surface by the object. The *highlight* is the lightest area on the object, where the reflection of light is strongest. *Reflected light*, often overlooked by beginners, is surrounding light that is reflected into the shadowed area of an object.

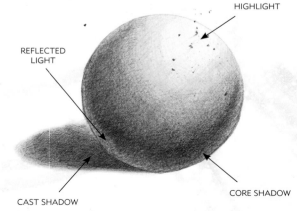

HIGHLIGHT

REFLECTED LIGHT

CAST SHADOW

CORE SHADOW

STEP-BY-STEP DRAWING METHOD

This book teaches the step-by-step drawing method and shows you how to draw a character using basic shapes. You will always begin by drawing very basic shapes, like lines and circles.

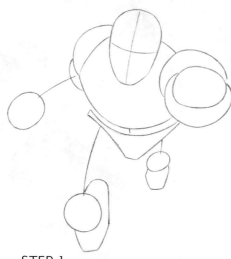

STEP 1

First draw the basic shapes, using light lines that will be easy to erase.

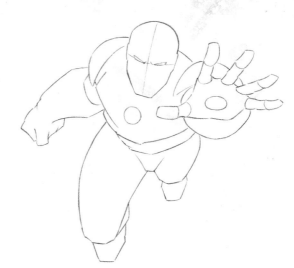

STEP 2

Erase guidelines and add more detail. Pay attention to the new lines added in each step.

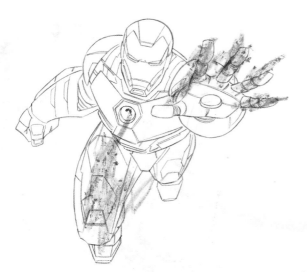

STEP 3

In each new step, add more defining lines. Take your time adding detail and copying what you see.

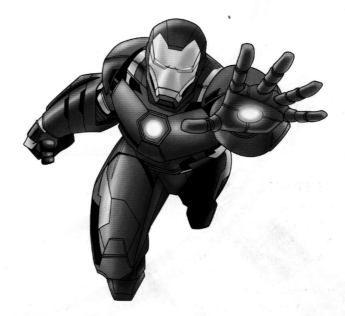

STEP 4

Add final details and shading. Then ink and color your drawing using whichever method you choose!

BASIC ANATOMY

The musculature of different individuals varies, but we all have the same muscles underneath our skin. Become familiar with basic anatomy so you can better envision the way the skin lays over the muscles to create the human form.

Front

Back

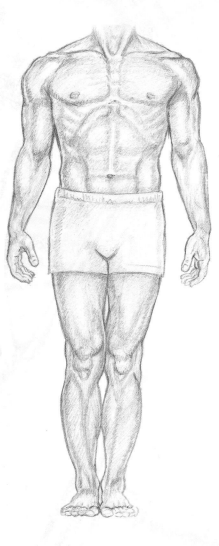

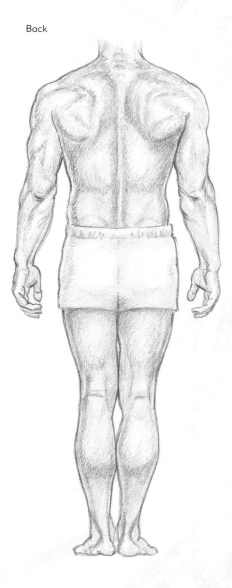

TORSO MUSCULATURE

(Front) The torso muscles—from the neck to the shoulders, across the chest, down and around the rib cage, and then from the hips to the legs— control the movement of the body and give form to the skeleton.

TORSO MUSCULATURE

(Back) The muscles in the back of the torso generally extend across the body, rather than up and down as in the front. They hold the body erect, stretching tightly across the back when the limbs move forward.

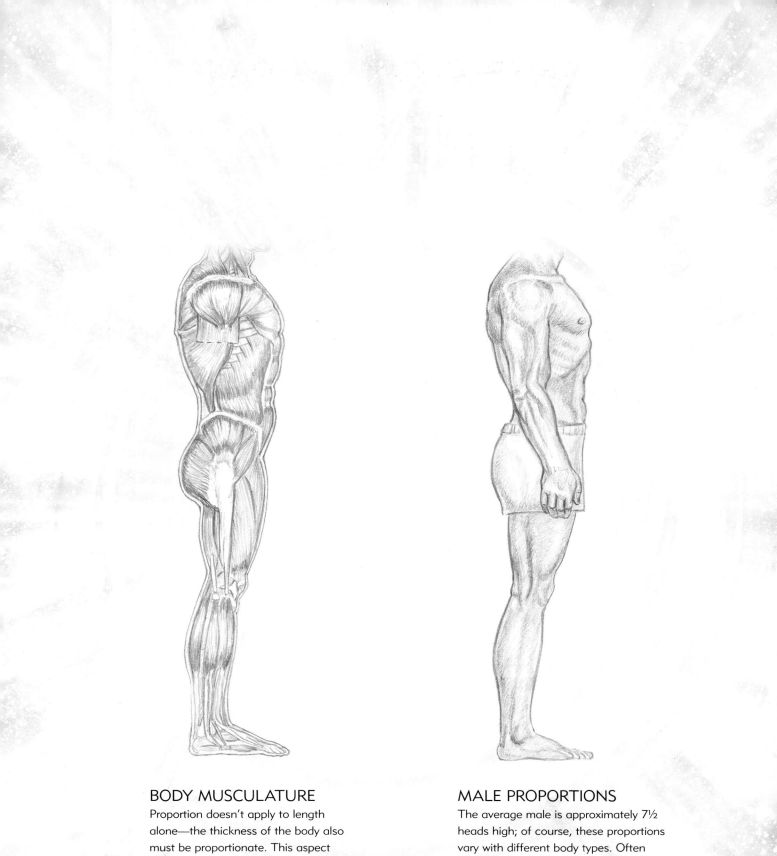

BODY MUSCULATURE

Proportion doesn't apply to length alone—the thickness of the body also must be proportionate. This aspect of proportion varies depending on the fitness of the individual, but the drawing above will help you assess these proportions based on an ideal human musculature.

MALE PROPORTIONS

The average male is approximately 7½ heads high; of course, these proportions vary with different body types. Often artists use an 8-head-high figure of the male as an ideal proportion.

INK & COLOR TECHNIQUES

In the early days of comic books, images were reproduced inexpensively using a very simple black-and-white photographic process. Most inking was done with india ink—preferred for its extremely dense black value. To create subtle tonal changes from solid black shadows to lighter areas, artists used hatching, cross-hatching, or "feathered" brushstrokes or pen strokes.

Today, improved reproduction techniques allow artists to explore various inking styles—but the iconic look of comic-style art owes much to those early inking techniques.

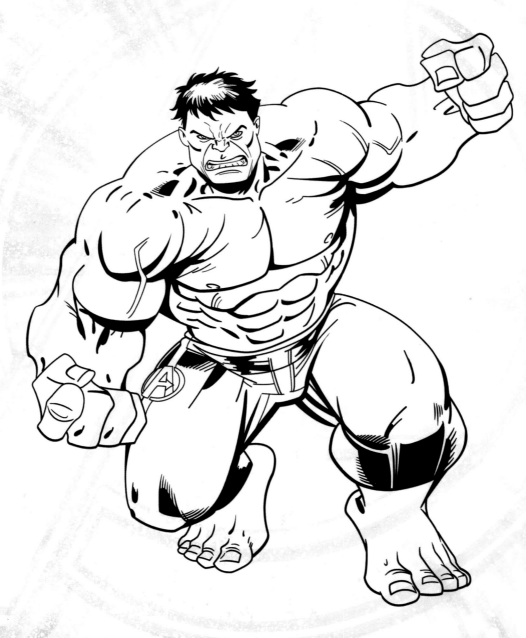

When inking, use various line weights and textures to define the shapes
and the image as a whole. Block out entire shapes in certain areas,
such as the hair or legs, to emphasize the shadows.

COLORING TECHNIQUES

You can color your drawings any way you'd like, using colored pencils, markers, paints, or digitally. Here, a professional comic book colorist describes the process for coloring the Hulk digitally using Adobe Photoshop®.

STEP 1

Add the base colors to the entire form. The Hulk's main colors are green for the body and purple for the pants.

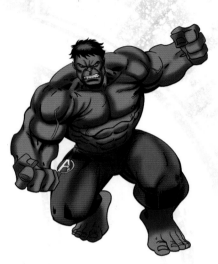

STEP 2

Look at the linework for signs of shadow placement and add darker shades of the base colors throughout the figure. The colorist chose a green for the base of the body and a darker green for the shapes that are in shadow. Do the same for all the base colors to give the figure more dimension and volume.

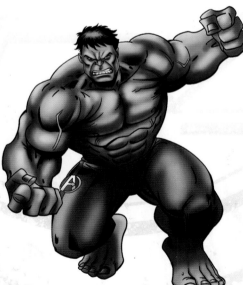

STEP 3

To bring out the highlights, the colorist used a yellow-green color. Focus on the places that reflect light strongest and use yellow-green and yellow to highlight these areas. Work the contours to round out the highlights and to keep things from looking flat. Don't use black or white, as it will bleach out or muddy your work. Repeat each color group until finished.

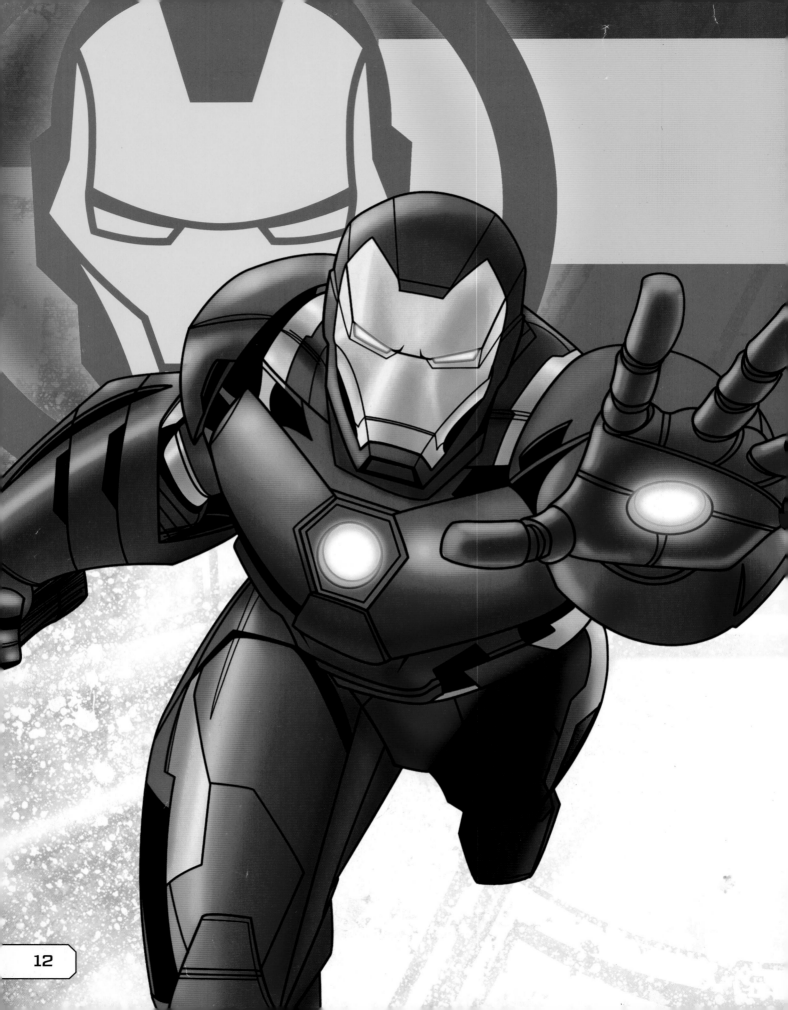

IRON MAN

BIO:
Wounded, captured, and forced to build a weapon by his enemies, billionaire industrialist Tony Stark instead created an advanced suit of armor to save his life and escape captivity. Now with a new outlook on life, Tony uses his money and intelligence to make the world a safer, better place as Iron Man.

REAL NAME:
Anthony "Tony" Stark

HEIGHT:
6'1" / 6'5" in armor

WEIGHT:
190 lbs. / 425 lbs. in armor

POWERS & ABILITIES:

• Has a genius-level intellect that allows him to invent a wide range of sophisticated devices, including advanced weapons and armor

• Possesses a keen business mind

• Shoots powerful particle beams, called repulsor rays, from the palms of his armor

• Has also outfitted his armor with pulse bolts (extremely powerful plasma discharges that grow in strength as they seek their target), sonic generators, explosive shell projectiles, mini-missiles, magnetic field generators, and a laser torch built into the finger of Tony's gauntlet

• Uses J.A.R.V.I.S. (Just A Rather Very Intelligent System), an A.I. system, which assists him at home and in his suit

Follow along, first drawing basic shapes with light pencil lines. Copy the new lines shown in each step, eventually darkening the lines you want to keep and erasing the rest. Finally, add color to your drawing.

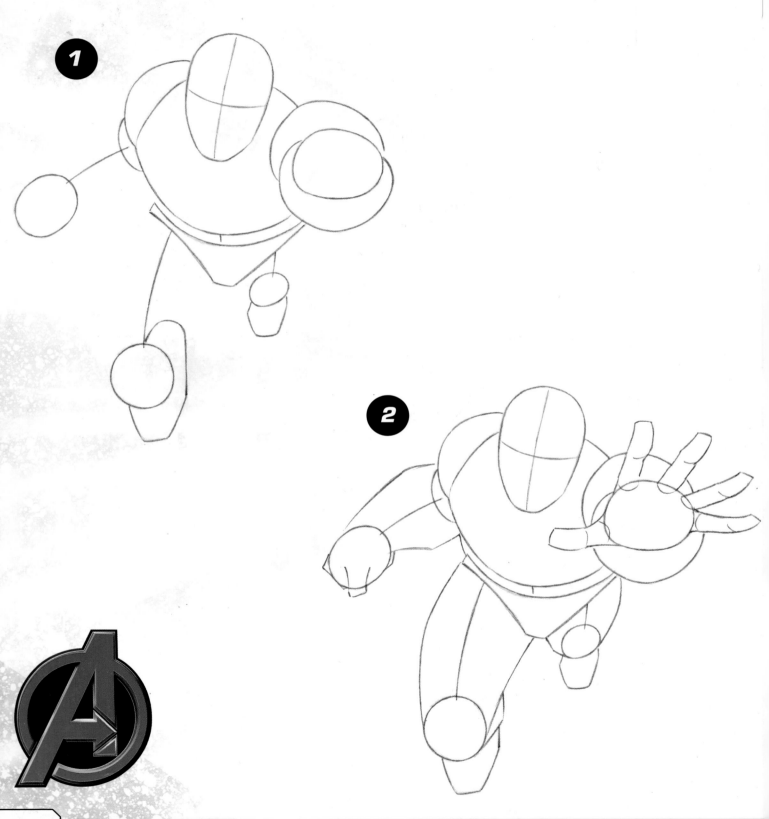

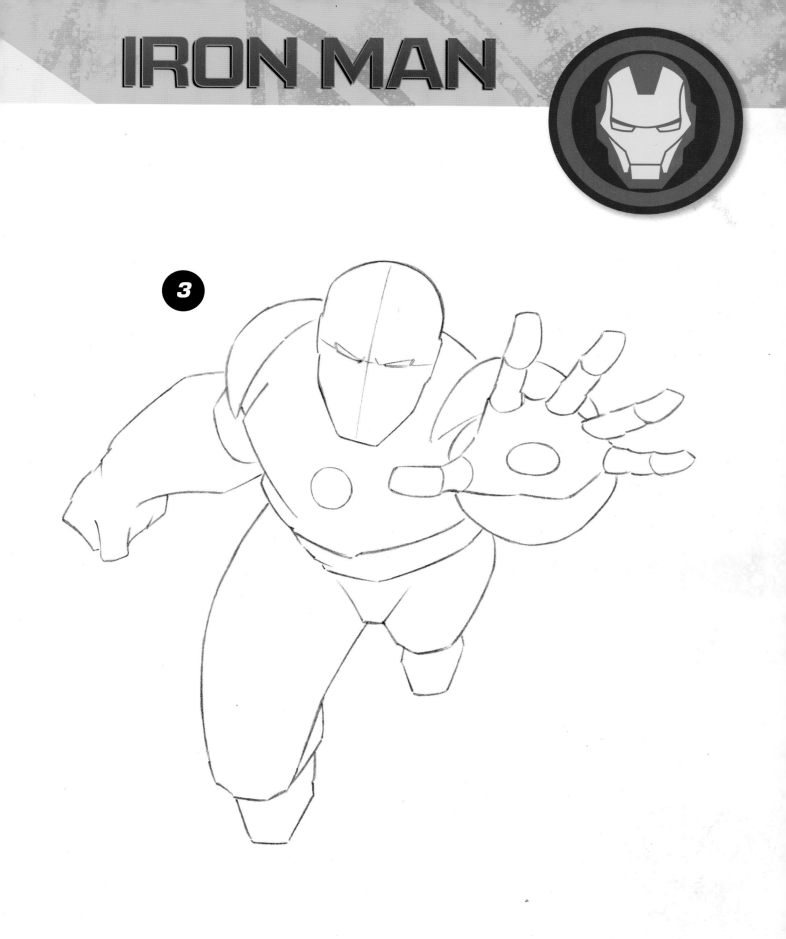

4

5

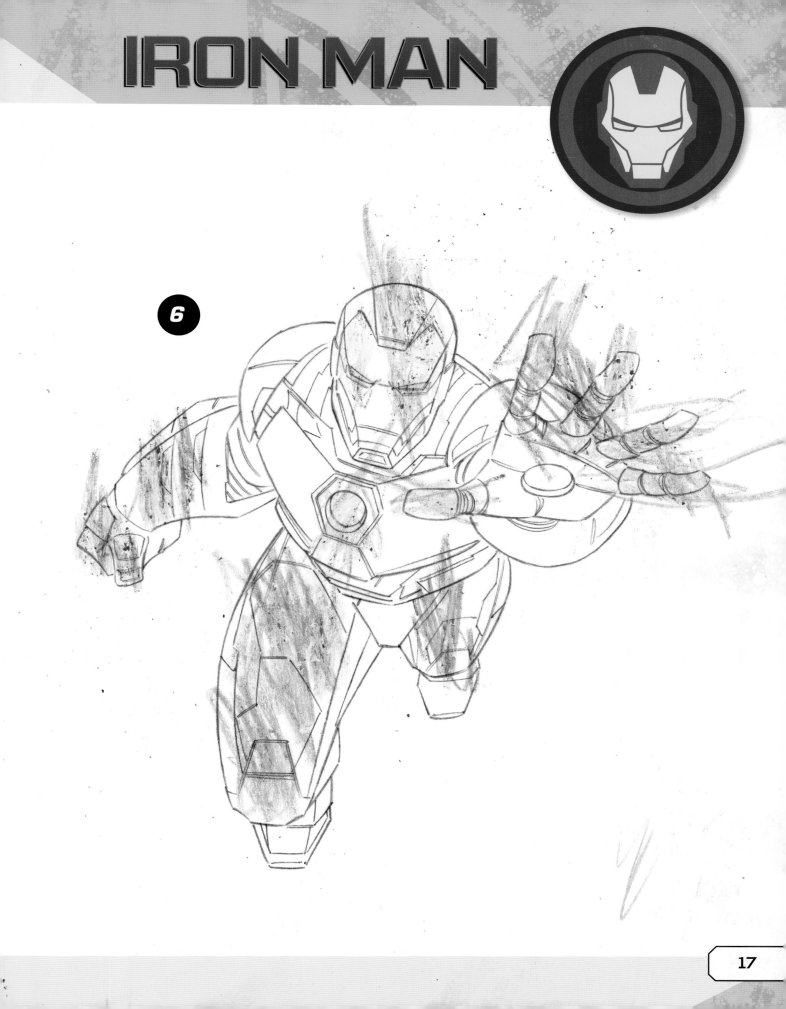

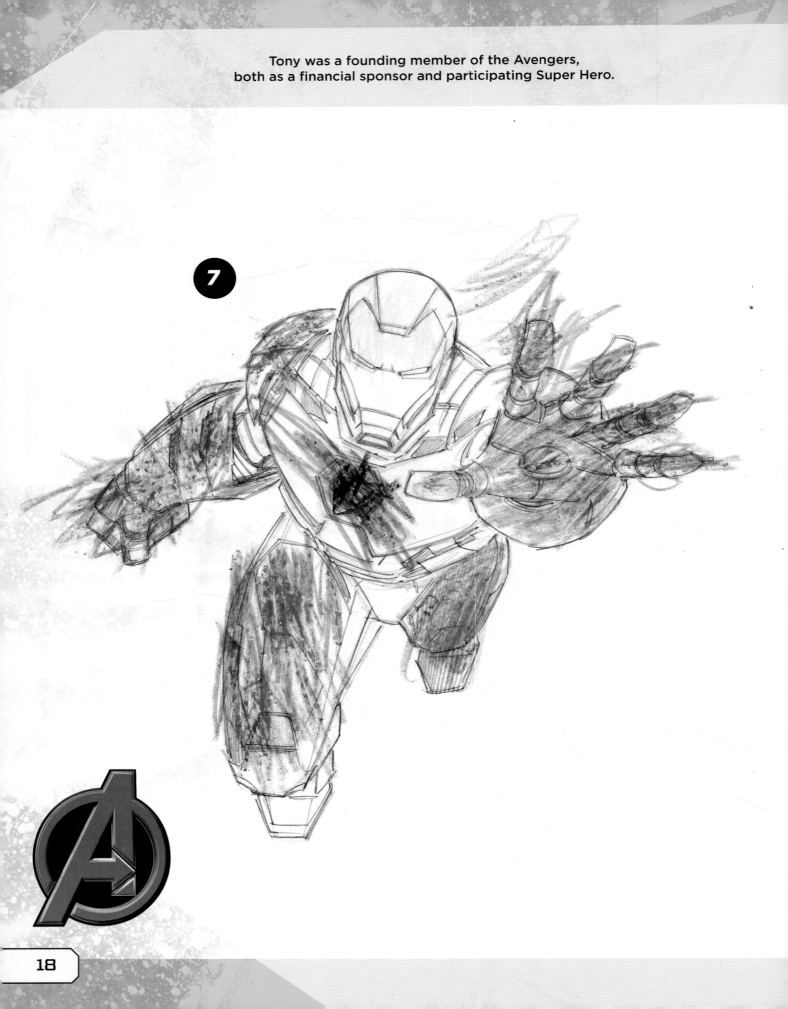

IRON MAN

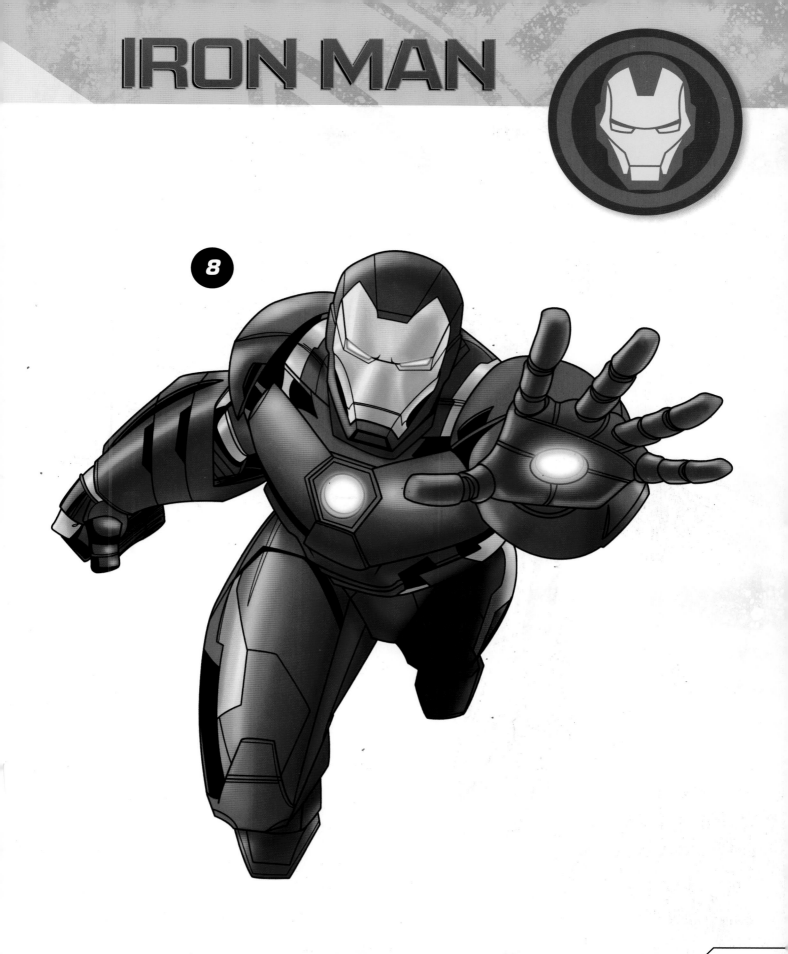

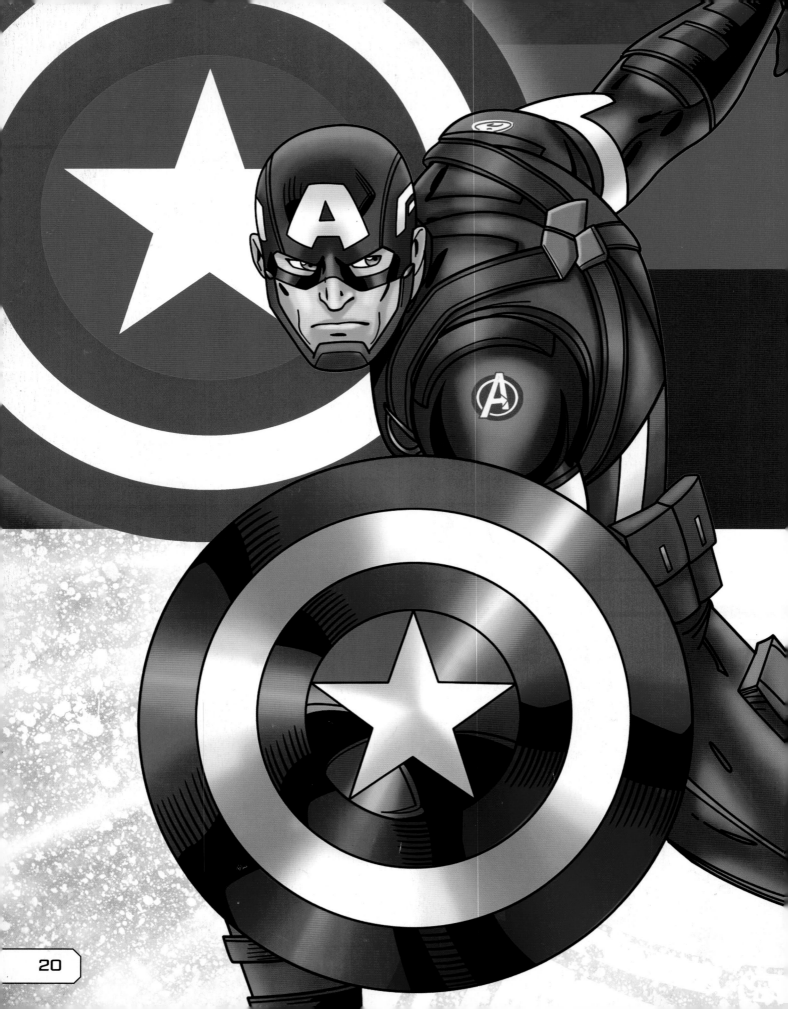

CAPTAIN AMERICA

BIO:

Vowing to serve his country any way he could, young Steve Rogers took the Super-Soldier serum to become America's one-man army. Fighting for the red, white, and blue for more than 60 years, Captain America is the living, breathing symbol of freedom and liberty.

REAL NAME:
Steven "Steve" Rogers

HEIGHT:
6'2"

WEIGHT:
230 lbs.

POWERS & ABILITIES:

• Has high intelligence, agility, strength, speed, endurance, and reaction time

• Is a master of American-style boxing and judo, and combines these disciplines with his own unique hand-to-hand style of combat

• Carries a virtually indestructible shield made of a unique Vibranium metal alloy, which can also be used as a weapon

Follow along, first drawing basic shapes with light pencil lines. Copy the new lines shown in each step, eventually darkening the lines you want to keep and erasing the rest. Finally, add color to your drawing.

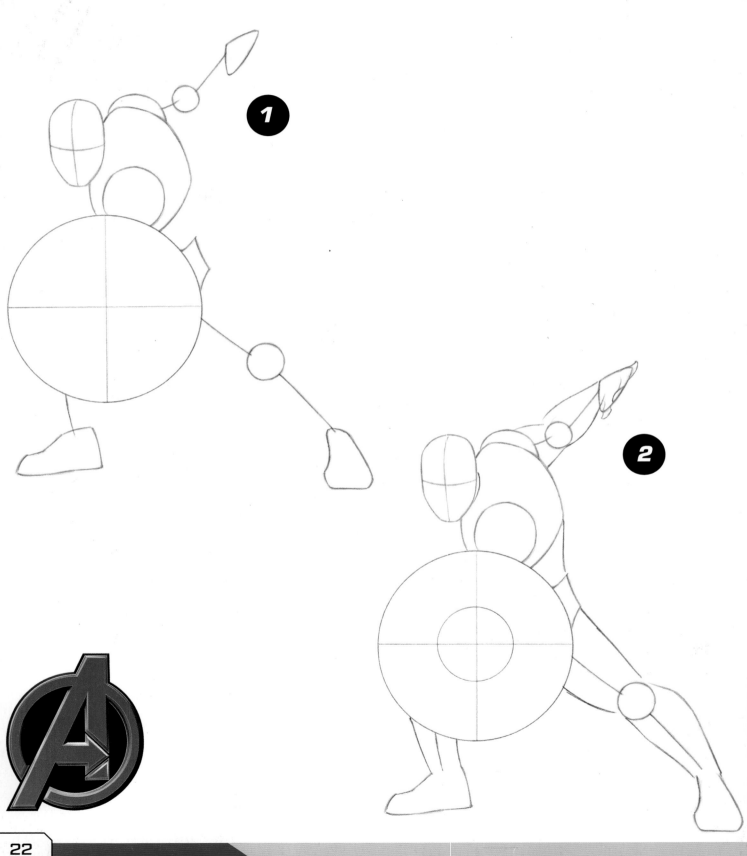

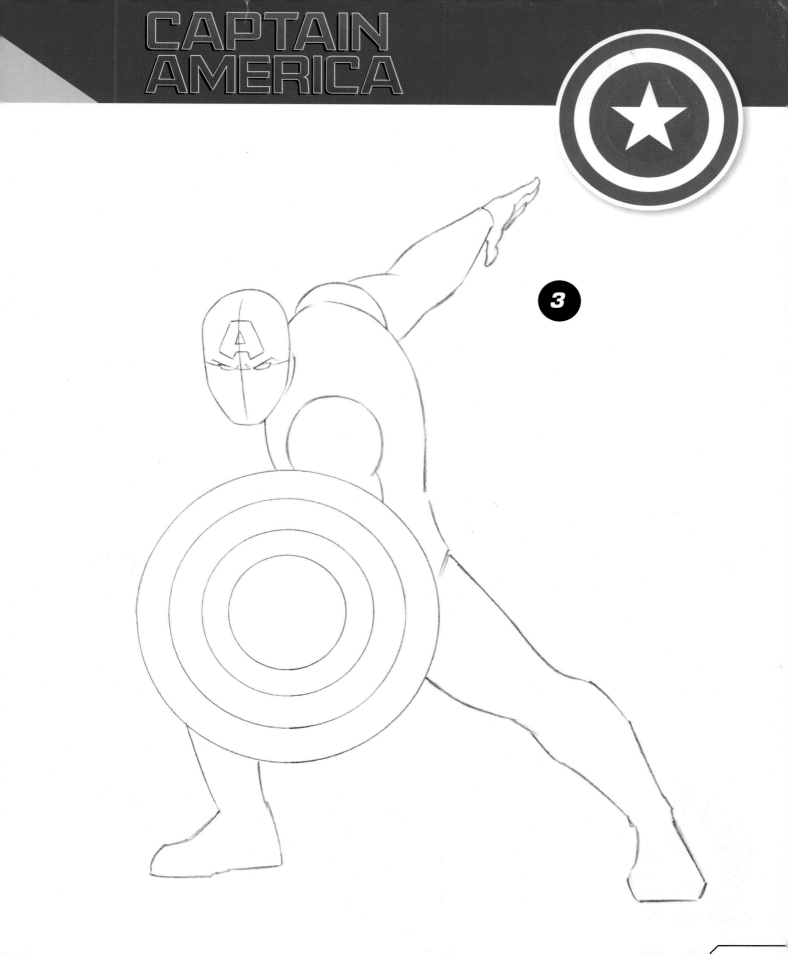

Captain America owes his powers and long life to Professor Abraham Erskine and Operation: Rebirth, a program that began during WWII to enhance U.S. soldiers.

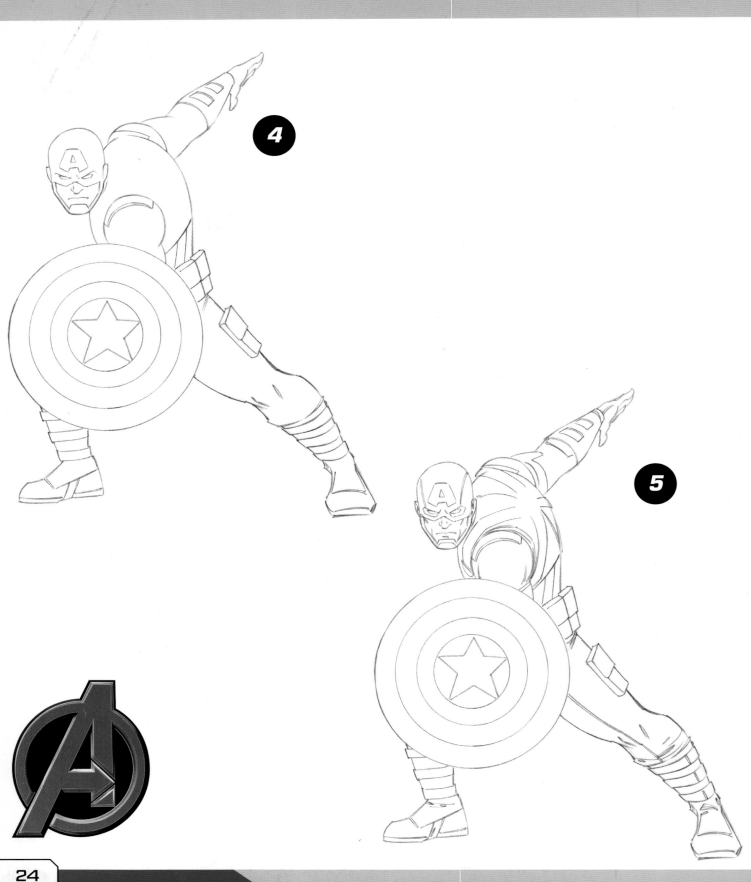

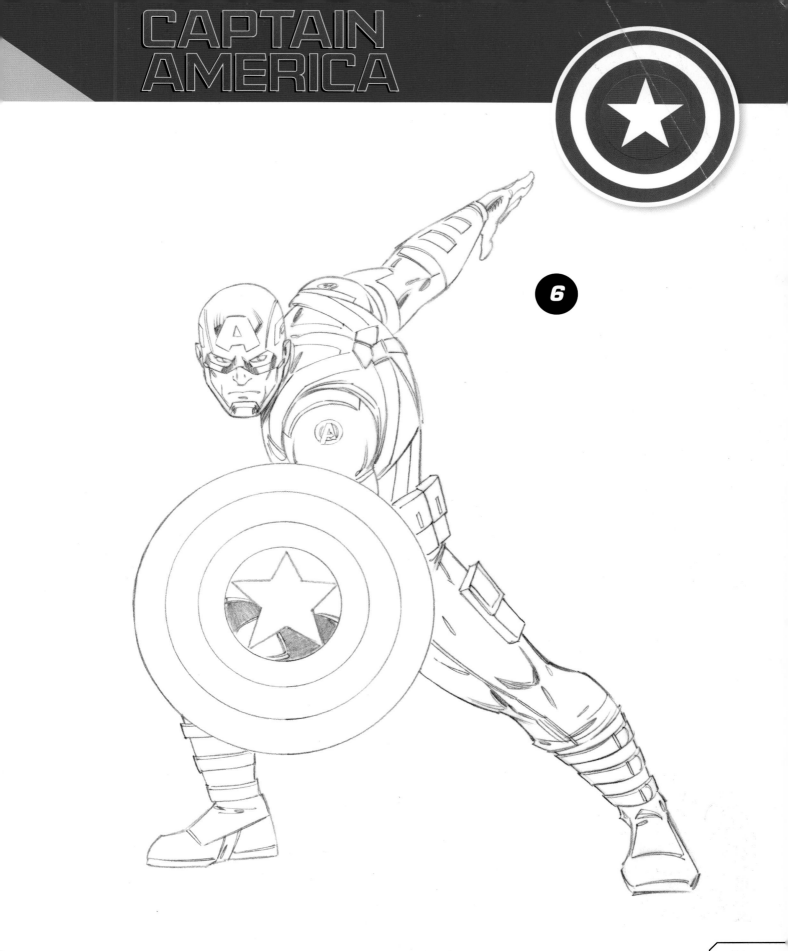

After original Avengers Super Heroes began taking long breaks from the group,
Steve Rogers became the Avengers' leader as the only remaining senior member.

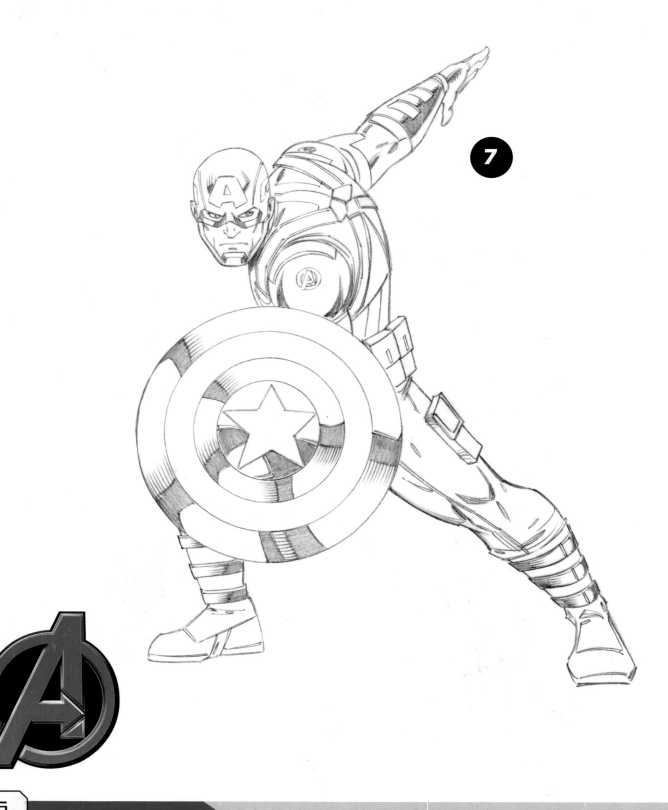

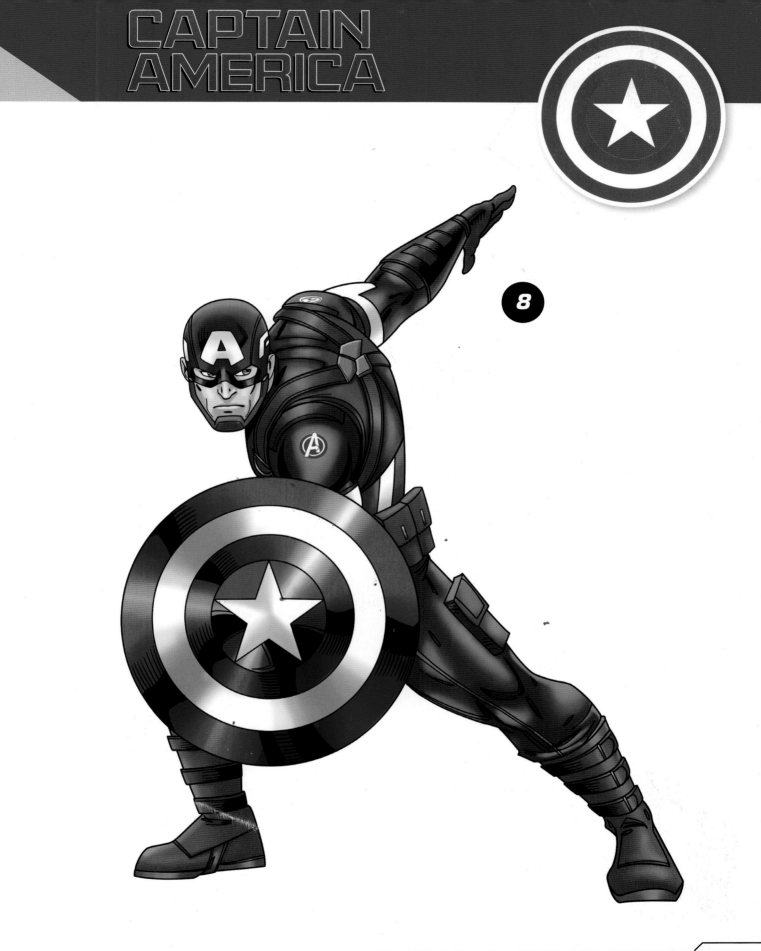

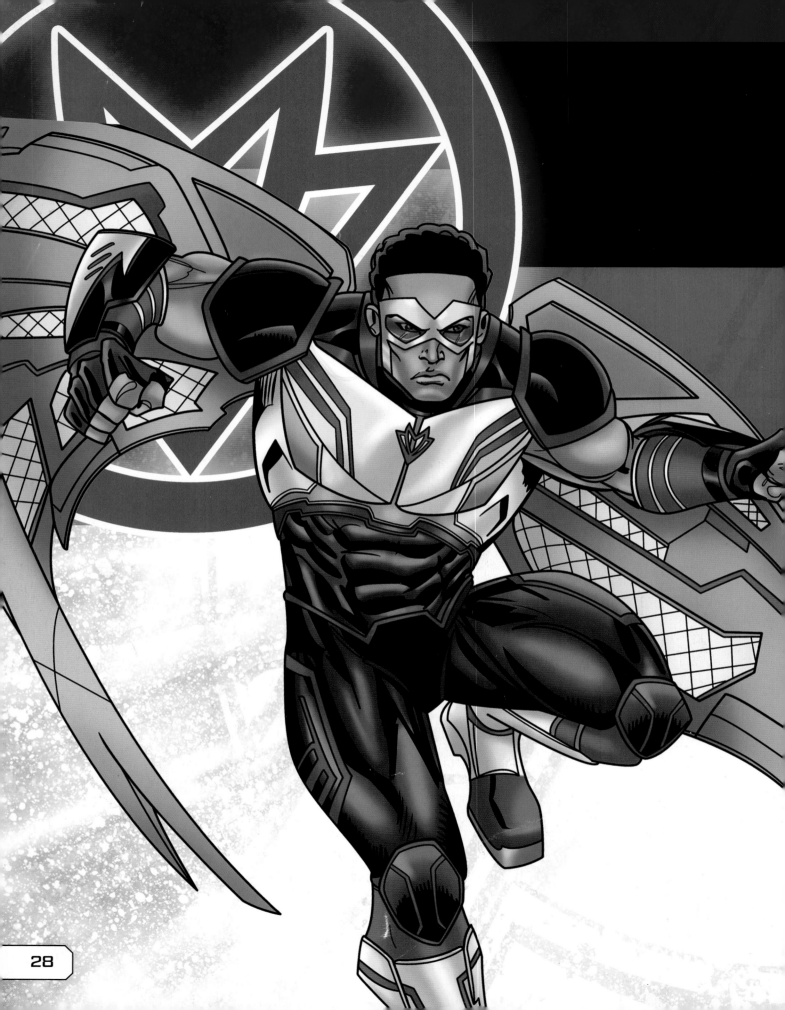

FALCON

BIO:

With a mental connection to all birds and a suit that gives him wings to fly, the Falcon has been both the partner to Captain America and an Avenger himself. Whether as a Super Hero or in his secret identity of social worker Sam Wilson, the Falcon dedicates his life to standing up for others.

POWERS & ABILITIES:

• Can telepathically communicate with birds and is able to receive mental images of what the birds see

• Is highly trained in gymnastics and hand-to-hand combat

• Wears a suit with glider wings that allow him to fly and maneuver at speeds of more than 250 miles per hour

REAL NAME:
Samuel Thomas "Sam" Wilson

HEIGHT:
6'0"

WEIGHT:
170 lbs.

Follow along, first drawing basic shapes with light pencil lines. Copy the new lines shown in each step, eventually darkening the lines you want to keep and erasing the rest. Finally, add color to your drawing.

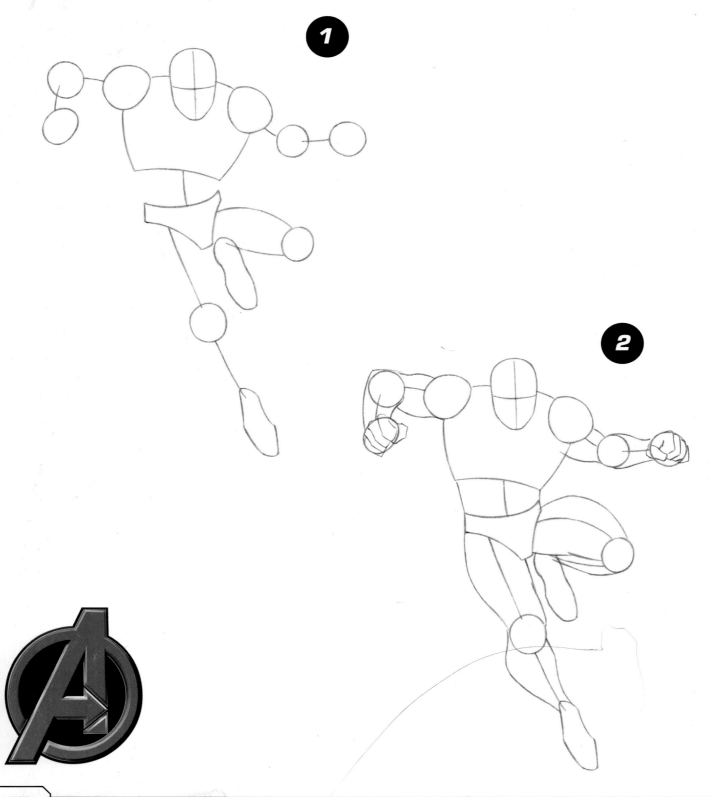

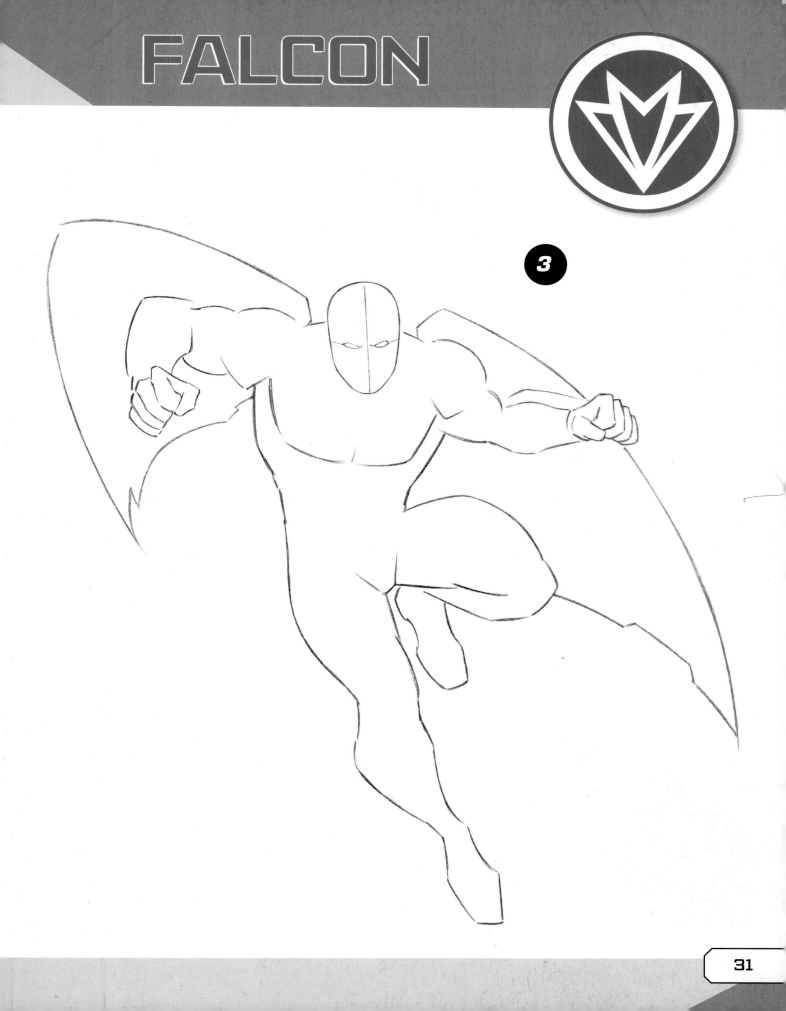

Sam, intelligent and adventurous, studied at S.H.I.E.L.D. and was at the top of his class.

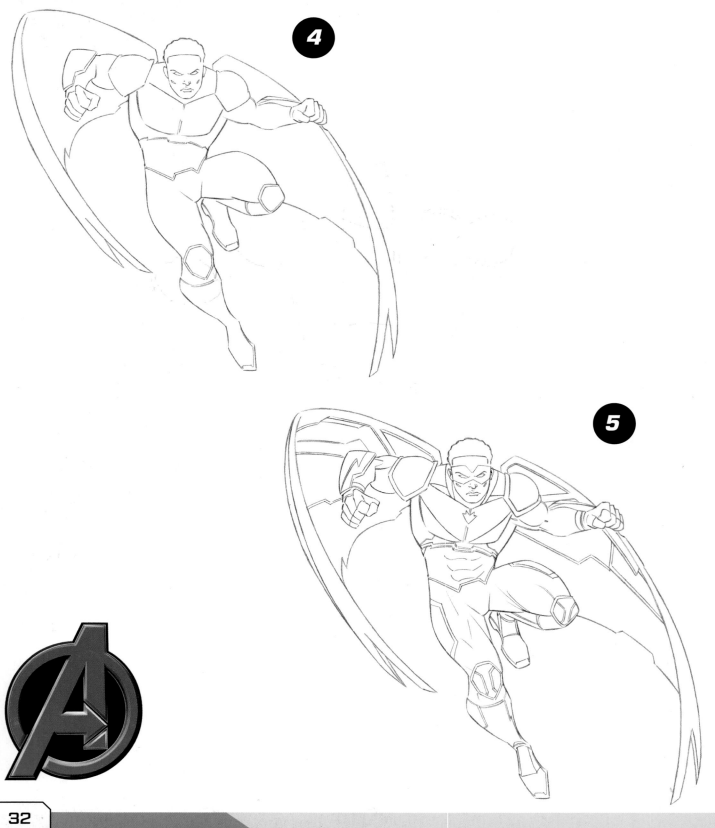

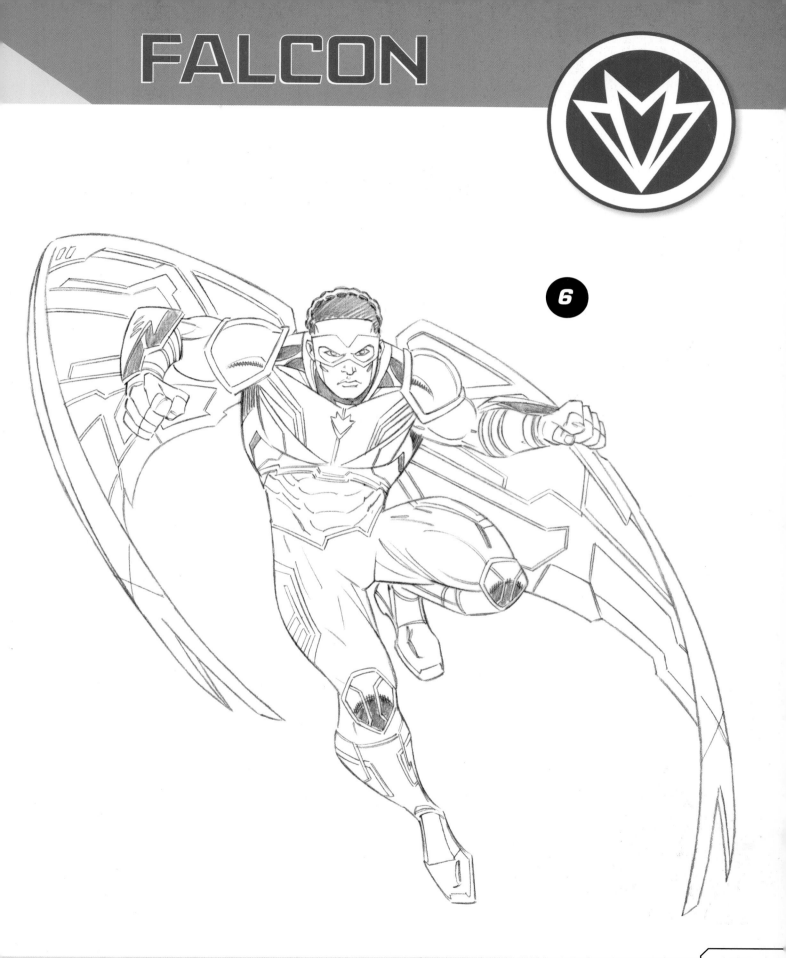

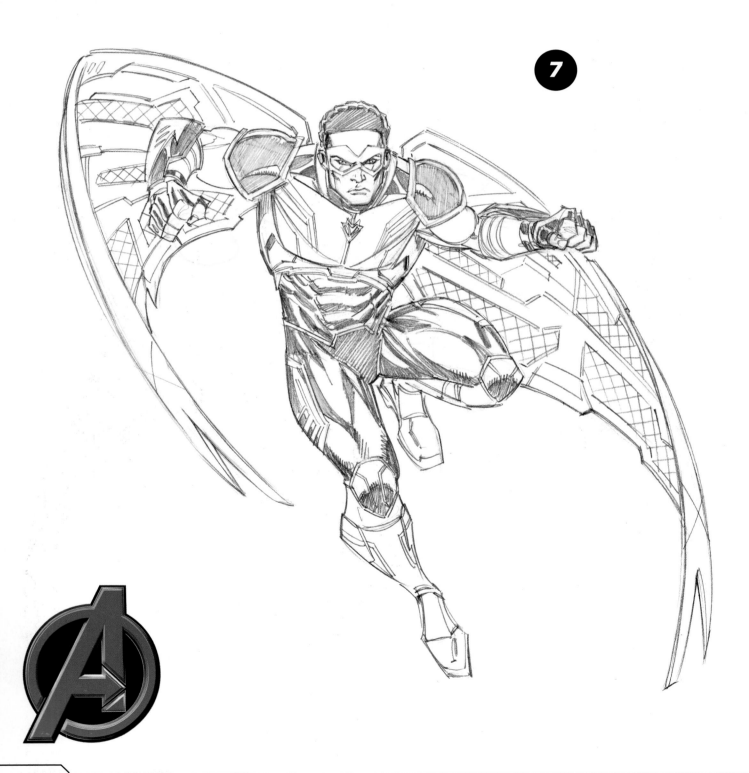

7

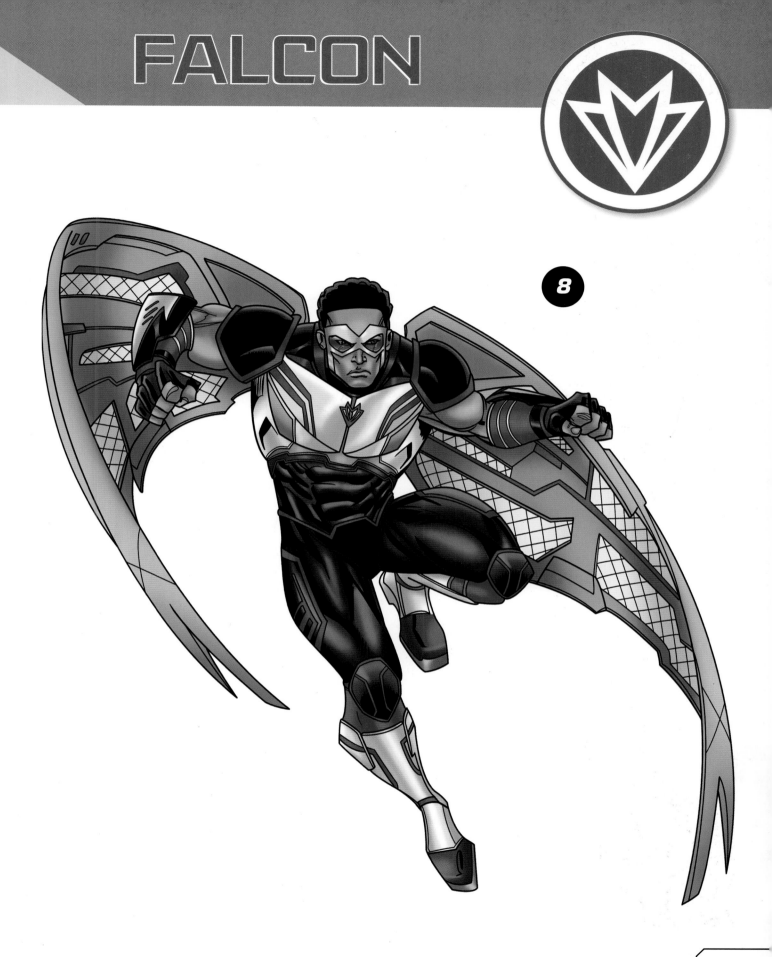

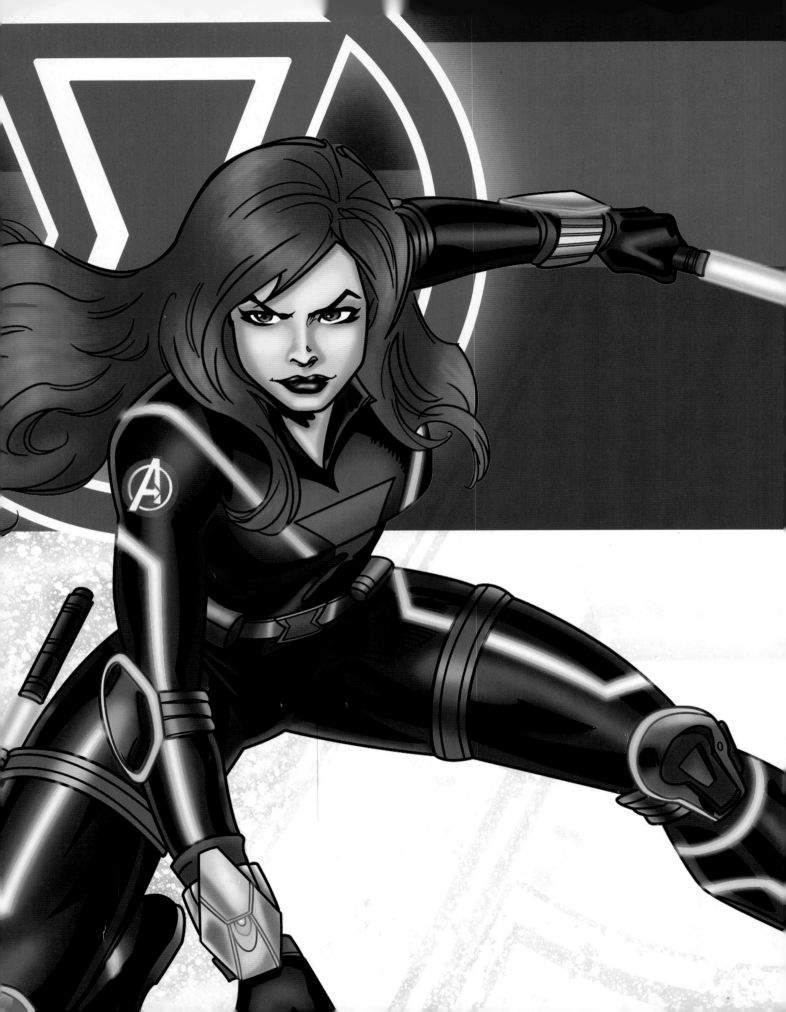

BLACK WIDOW

BIO:

Natasha Romanoff, known by many aliases, is an expert spy, athlete, and assassin. Trained at a young age by the KGB's infamous Red Room Academy, the Black Widow was formerly an enemy to the Avengers. She became their ally after breaking out of the U.S.S.R.'s grasp, and now serves as a top agent of S.H.I.E.L.D.

REAL NAME:
Natalia "Natasha" Romanoff

HEIGHT:
5'7"

WEIGHT:
130 lbs.

POWERS & ABILITIES:

• Ages slowly, has an augmented immune system and enhanced physical durability due to Soviet government training and treatments

• Wears bracelets that are equipped to discharge the "widow's bite," high-frequency electrostatic bolts of up to 30,000 volts; shoot tear gas cartridges; and act as a radio transmitter

• Can carry plastic explosive discs equivalent to 4 pounds of TNT in her belt and use automatic weapons and/or combat knives as necessary

• Wears a suit composed of a Kevlar-like substance designed for maximum protective qualities

Follow along, first drawing basic shapes with light pencil lines. Copy the new lines shown in each step, eventually darkening the lines you want to keep and erasing the rest. Finally, add color to your drawing.

1

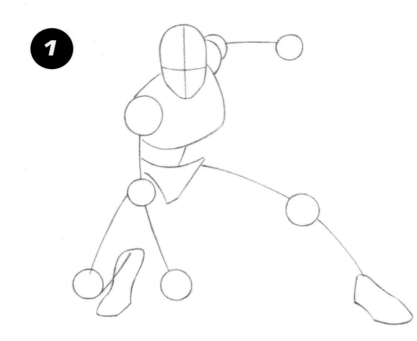

2

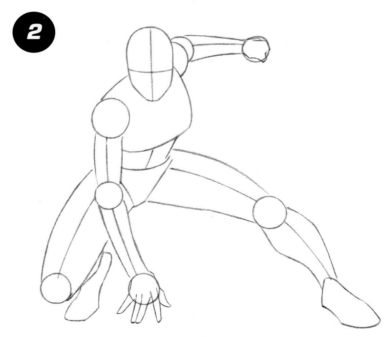

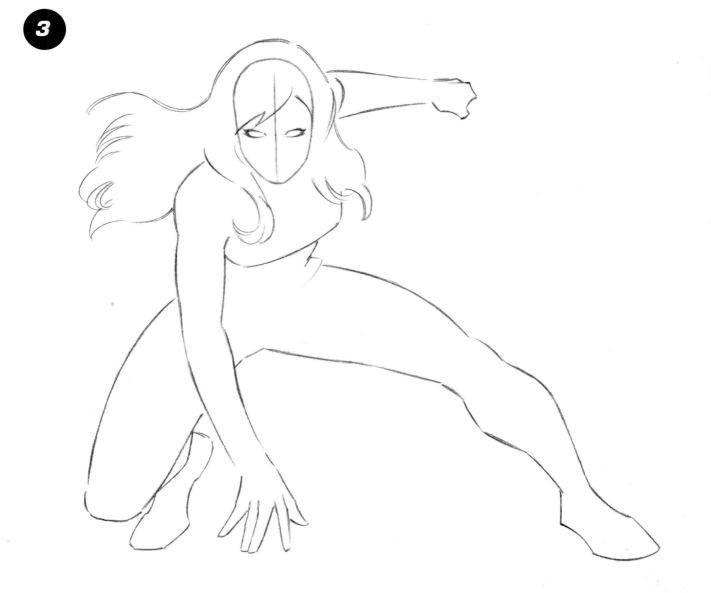

Natasha studied as a ballerina to cover for her true occupation,
a sleeper agent who spied on the United States.

4

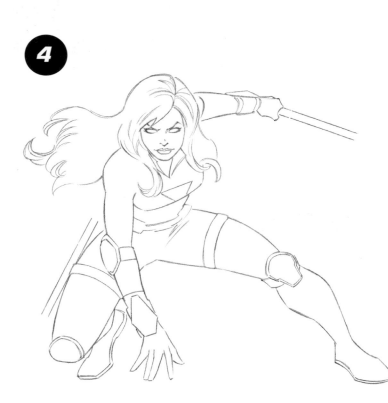

5

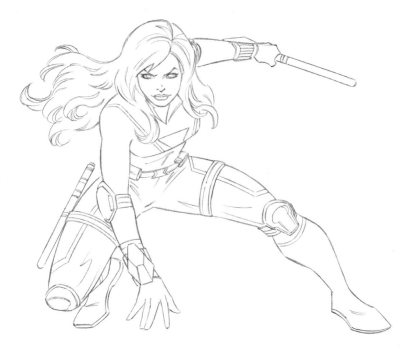

6

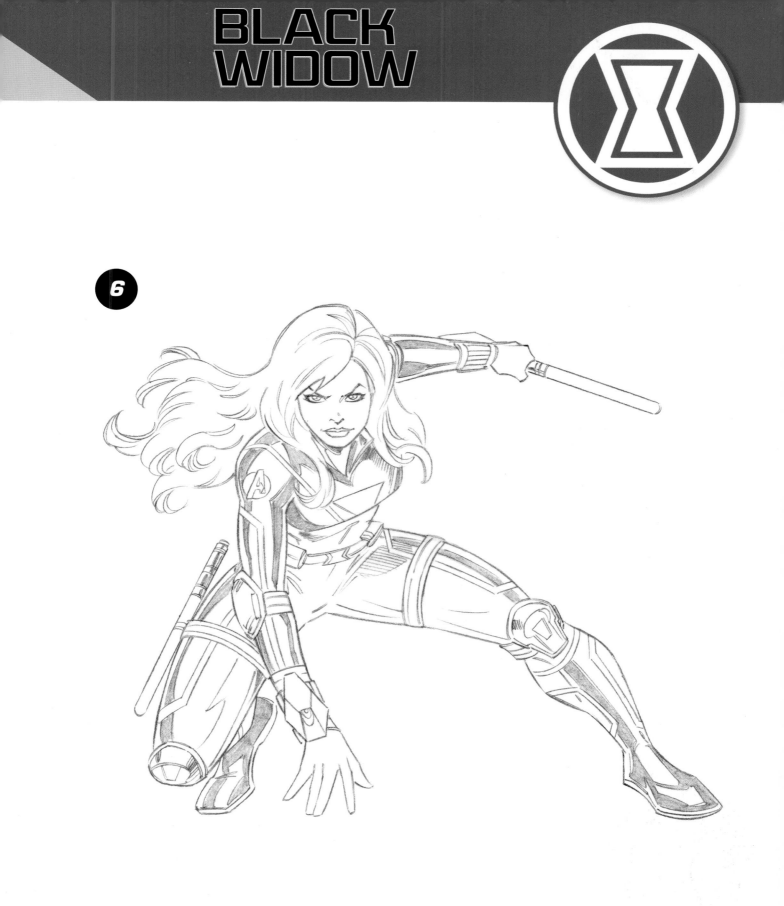

Natasha's connection with Hawkeye led her to defect from her original keepers and right the wrongs of her past by joining S.H.I.E.L.D., which eventually led her to join the Avengers.

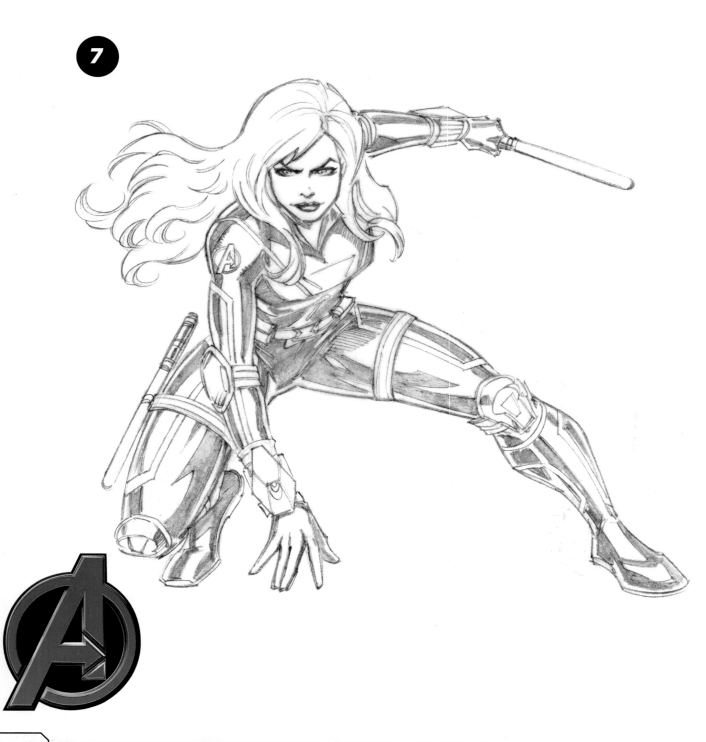

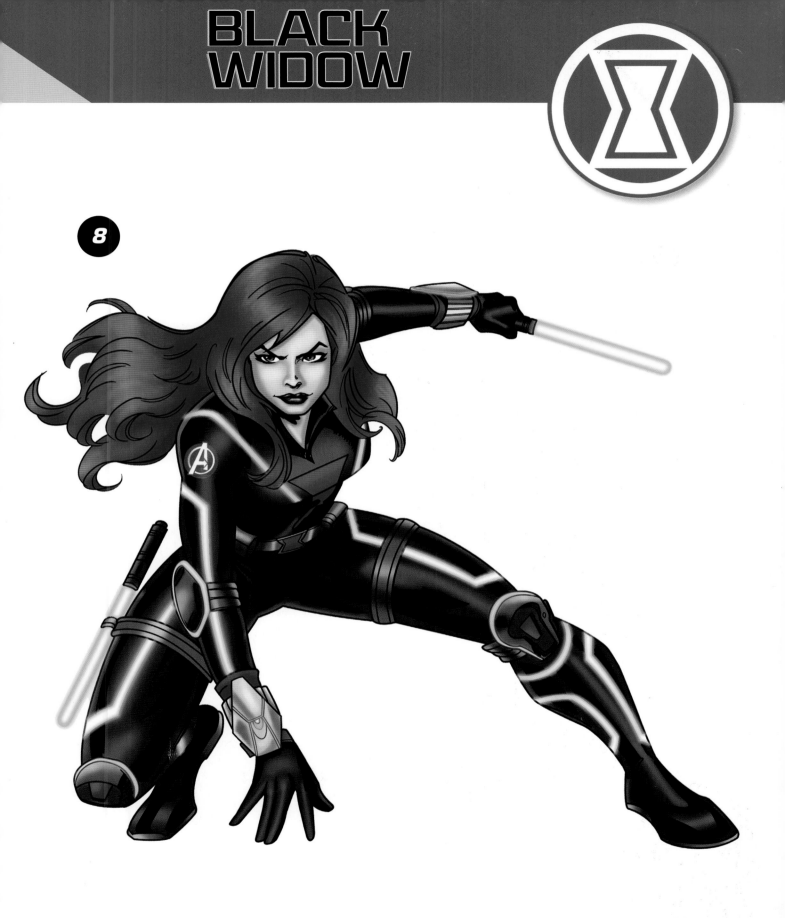

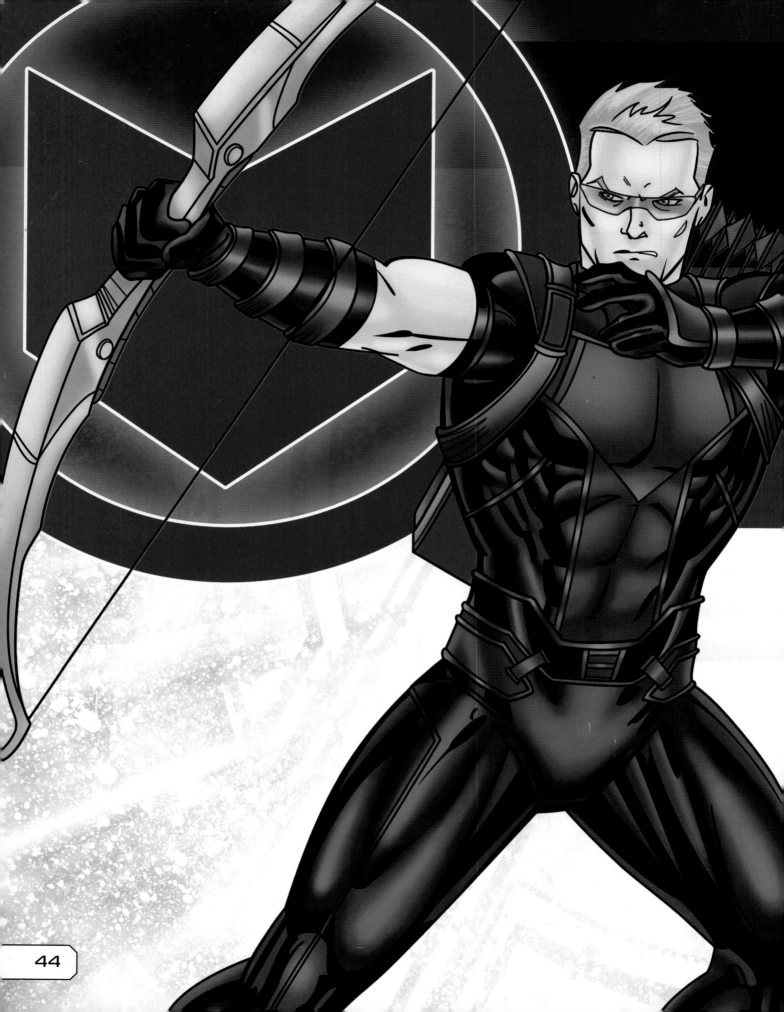

HAWKEYE

BIO:

Trained by Trick Shot, Clint Barton is the most proficient archer ever known. He is also a gifted acrobat and aerialist with great skill with weapons and hand-to-hand combat. After seeing Iron Man in action, he was inspired to become a costumed crime-fighter himself. He met his longtime friend Black Widow before joining the Avengers team.

REAL NAME:
Clinton Francis "Clint" Barton

HEIGHT:
6'0"

WEIGHT:
185 lbs.

POWERS & ABILITIES:

• Is a world-class archer and marksman with above-average reflexes and hand-eye coordination

• Throws knives, darts, balls, bolas, and boomerangs

• Is a formidable unarmed combatant, thanks largely to longtime combat training with Captain America

• Designs weapons, particularly arrows, blades, and hand-thrown projectiles

• Pilots the Avengers' supersonic Quinjets and other aircraft

Follow along, first drawing basic shapes with light pencil lines. Copy the new lines shown in each step, eventually darkening the lines you want to keep and erasing the rest. Finally, add color to your drawing.

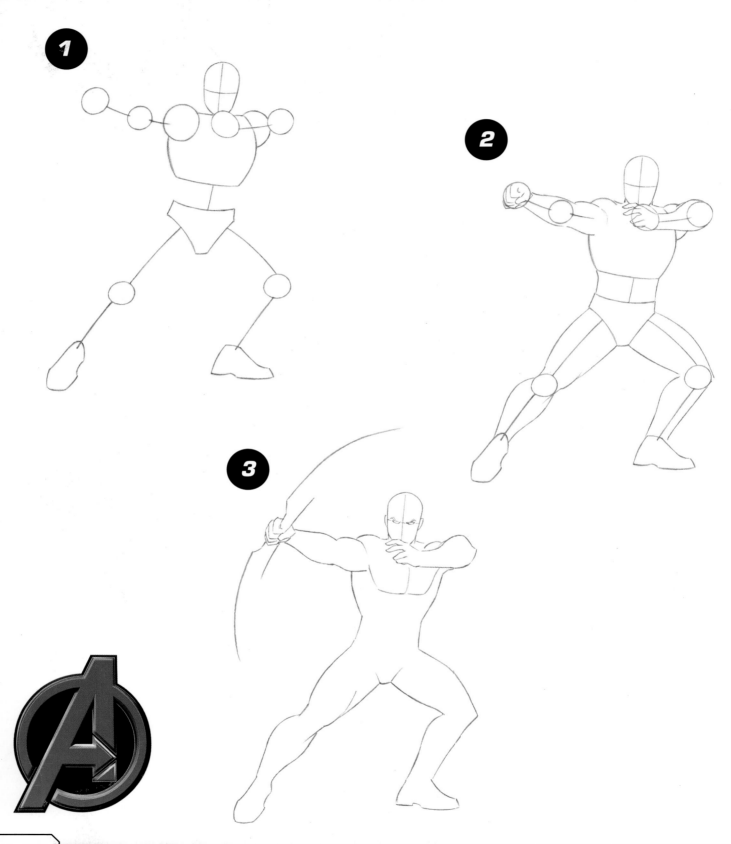

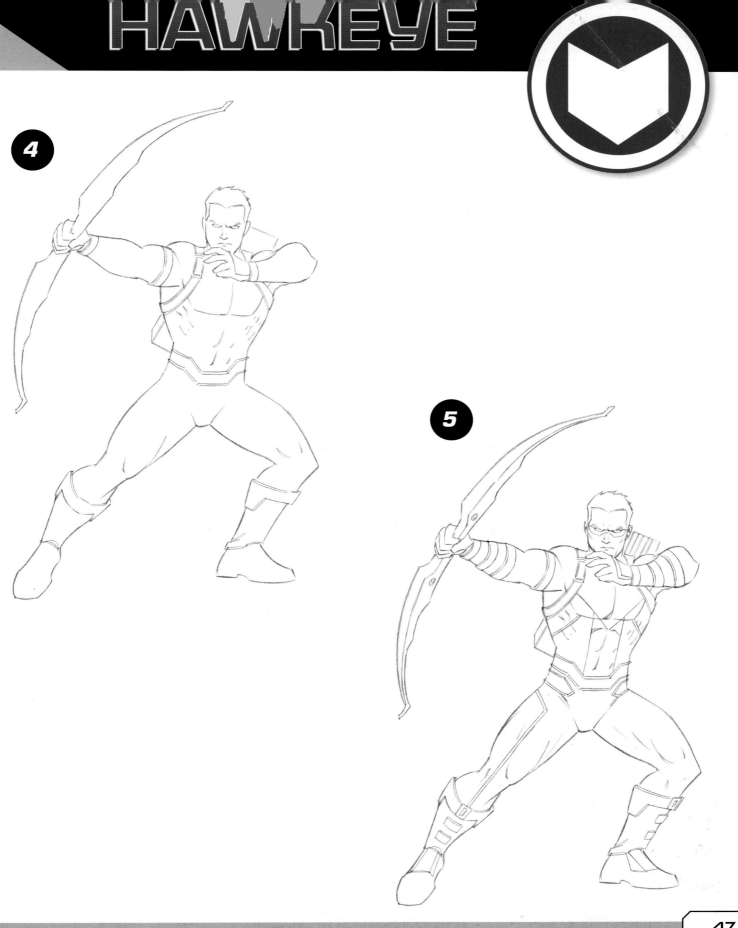

While working as a roustabout for a traveling circus, Clint Barton learned how to use a bow and arrow. After seeing Iron Man's heroics in person, Clint decided to become a costumed hero, as well.

6

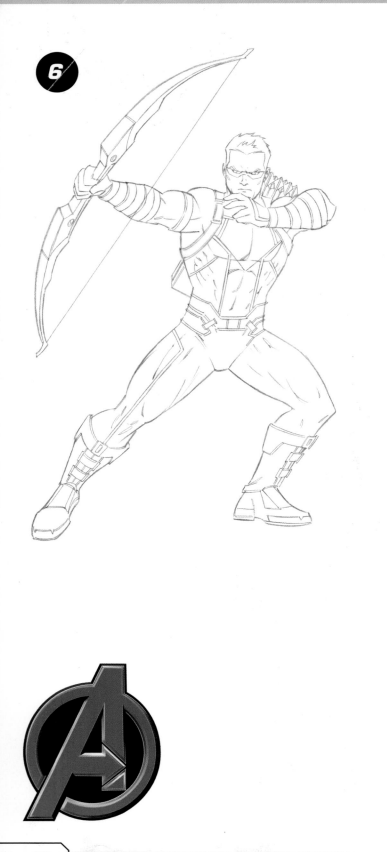

7

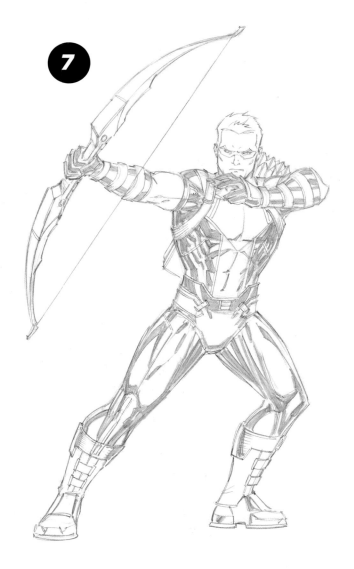

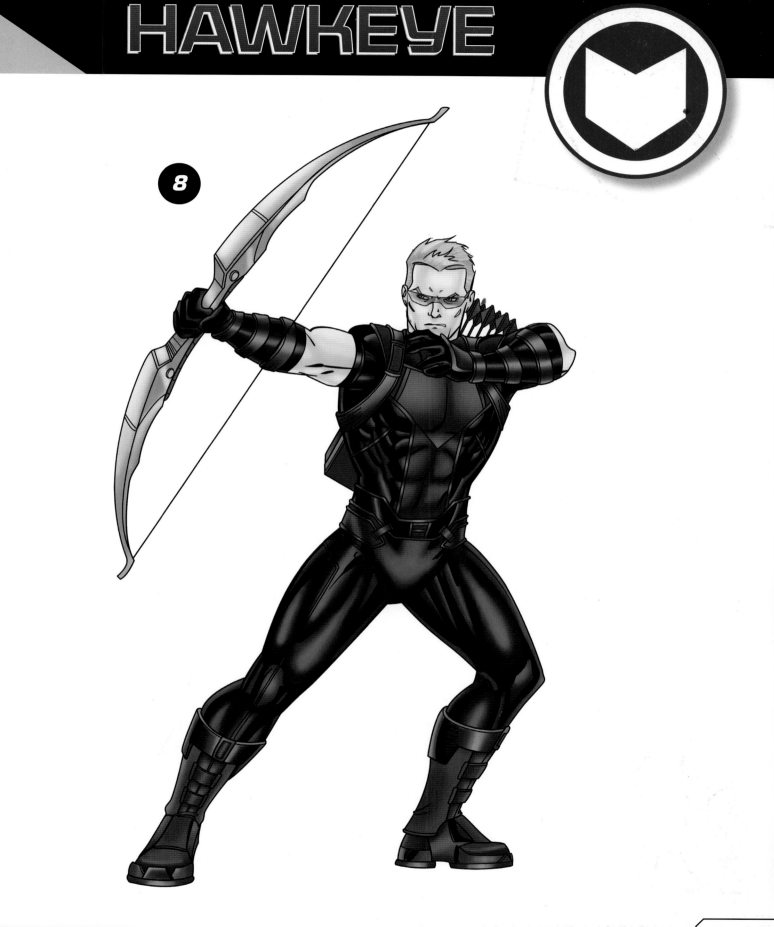

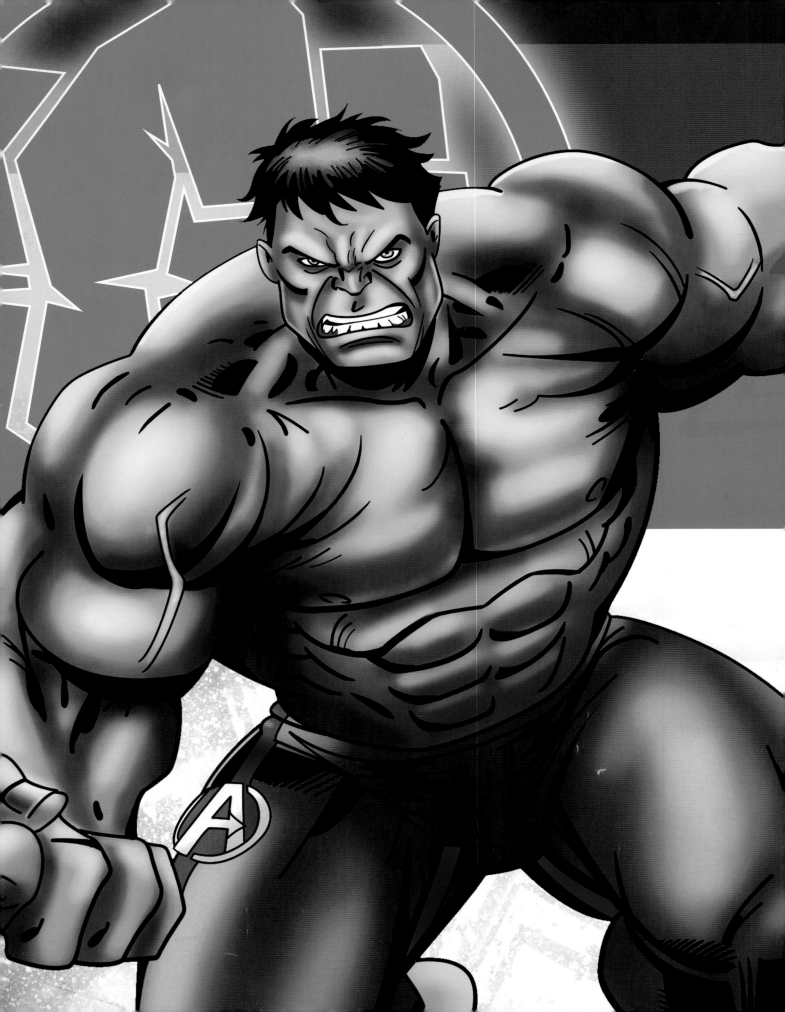

HULK

BIO:

After being exposed to harmful gamma rays, Dr. Bruce Banner was transformed into the incredibly powerful creature called the Hulk. Dr. Bruce Banner is brilliant and a genius in nuclear physics, but when he is the Hulk, Banner's consciousness is buried within. Banner can influence the Hulk's behavior only to a very limited extent.

REAL NAME:
Robert Bruce Banner

HEIGHT:
5'9" / 8'5" as Hulk

WEIGHT:
145 lbs. / 1,040 lbs.
 as Hulk

POWERS & ABILITIES:

• Has potentially limitless physical strength due to the fact that the Hulk's strength increases proportionally with his level of emotional stress

• Leaps great distances, and has been known to cover hundreds of miles in a single bound

• Slams his hands together to create shock waves, which can deafen people, send objects flying, and extinguish fires

• Has superhuman endurance

Follow along, first drawing basic shapes with light pencil lines. Copy the new lines shown in each step, eventually darkening the lines you want to keep and erasing the rest. Finally, add color to your drawing.

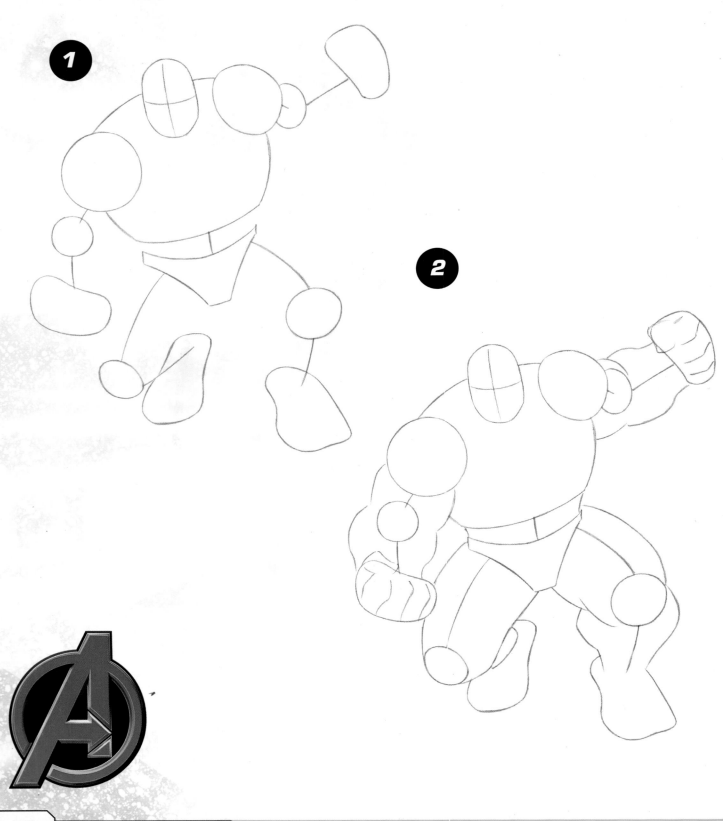

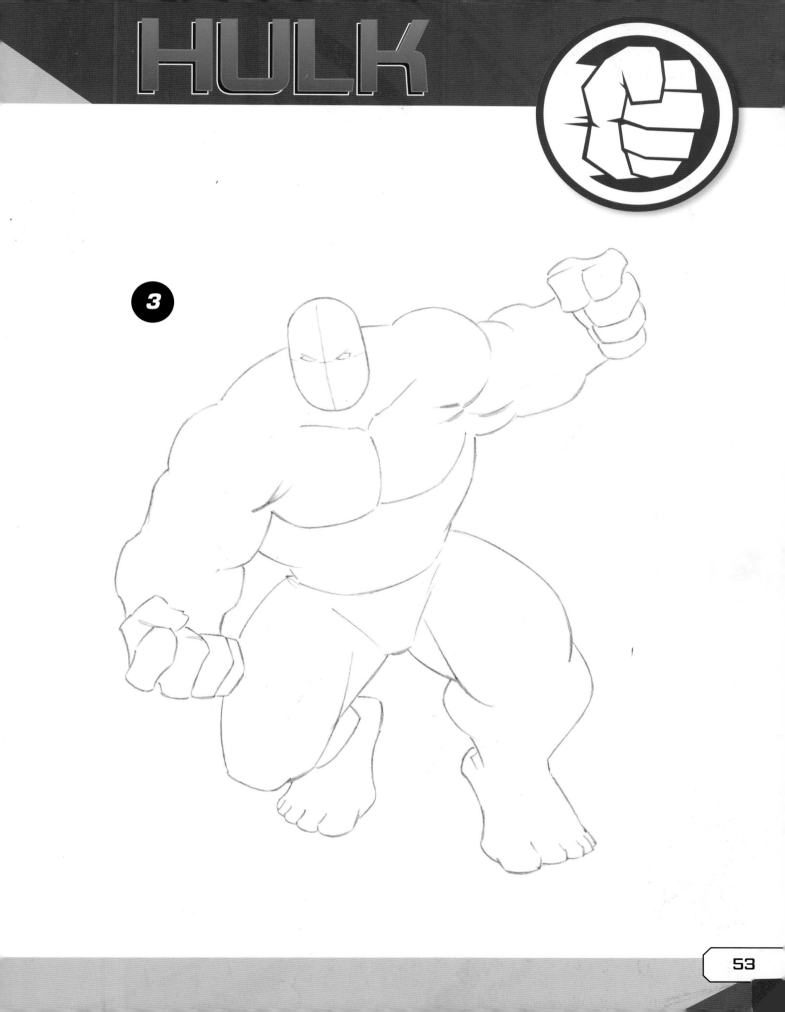

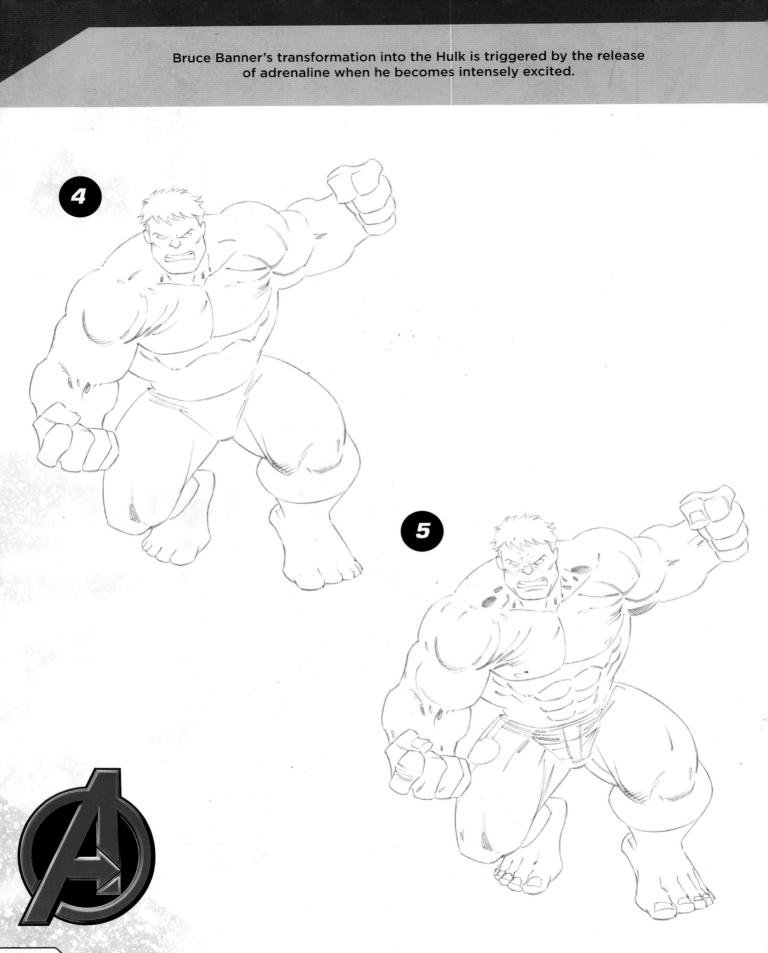

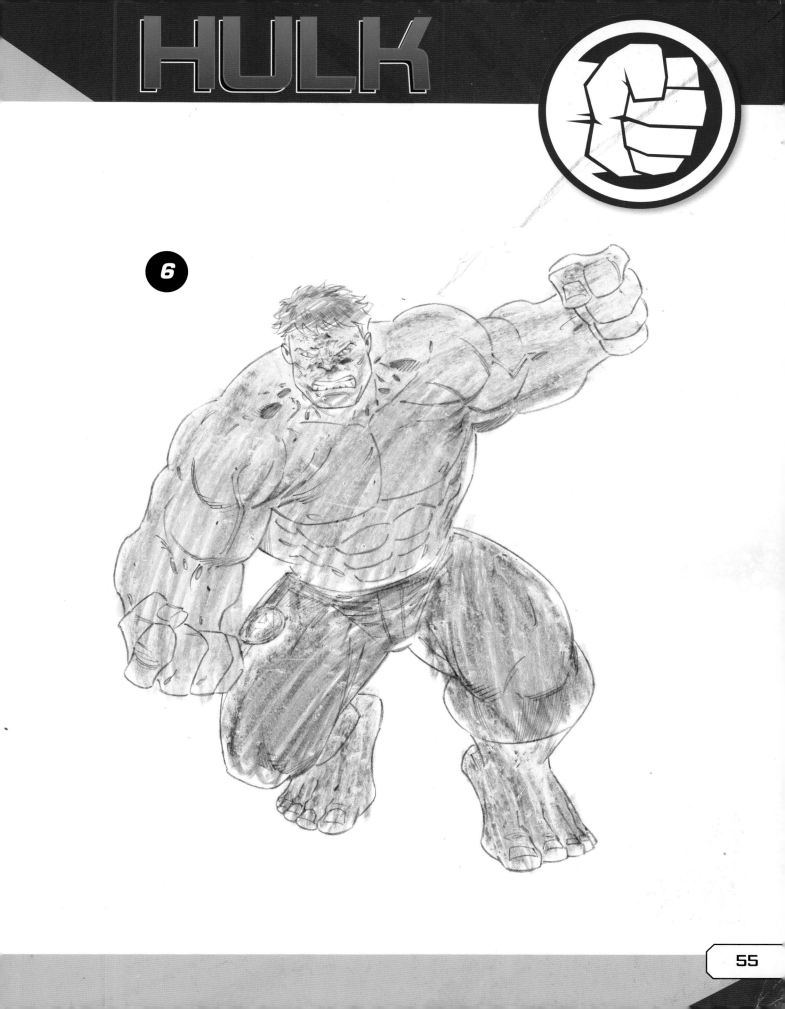

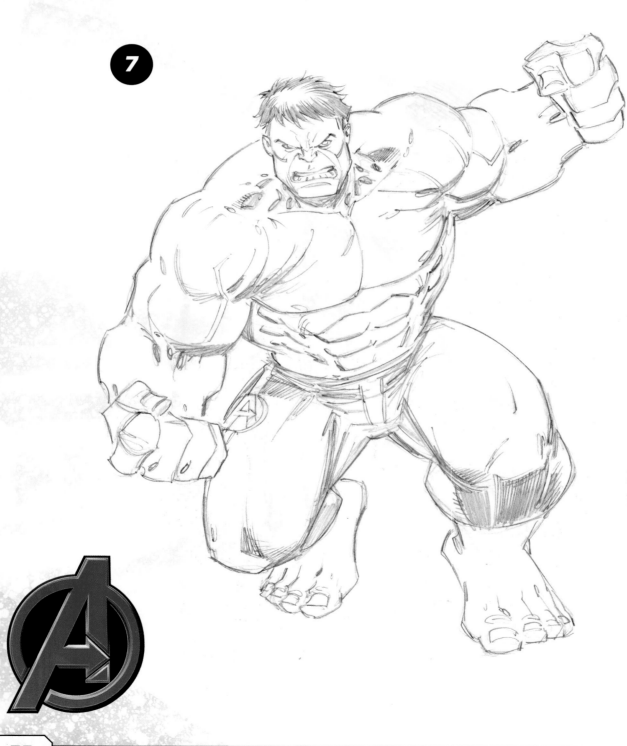

HULK

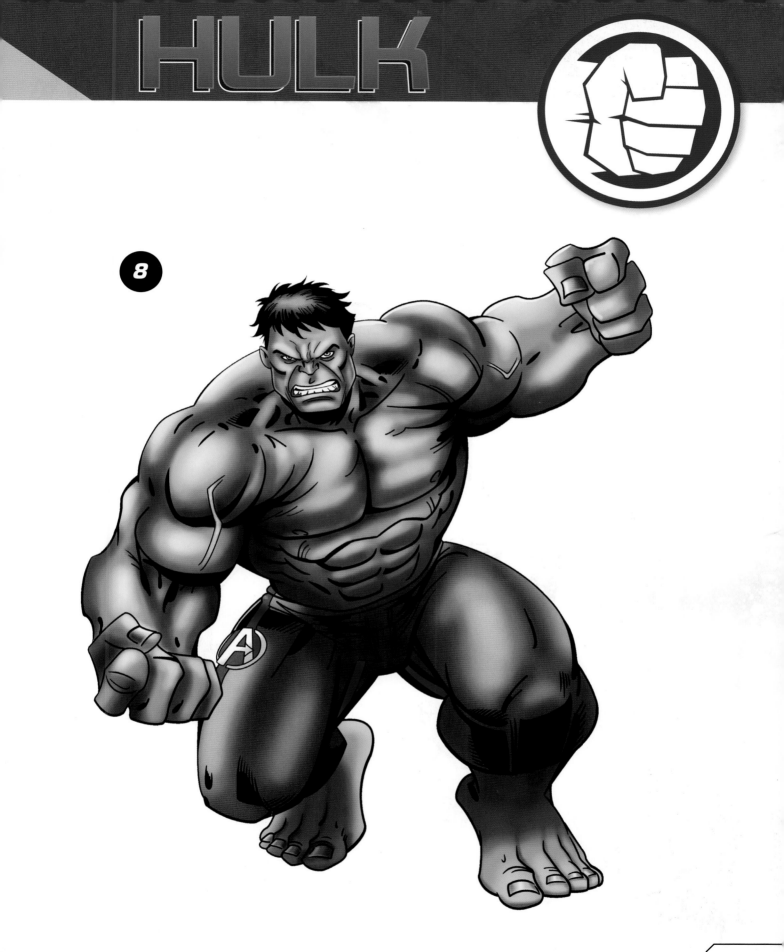

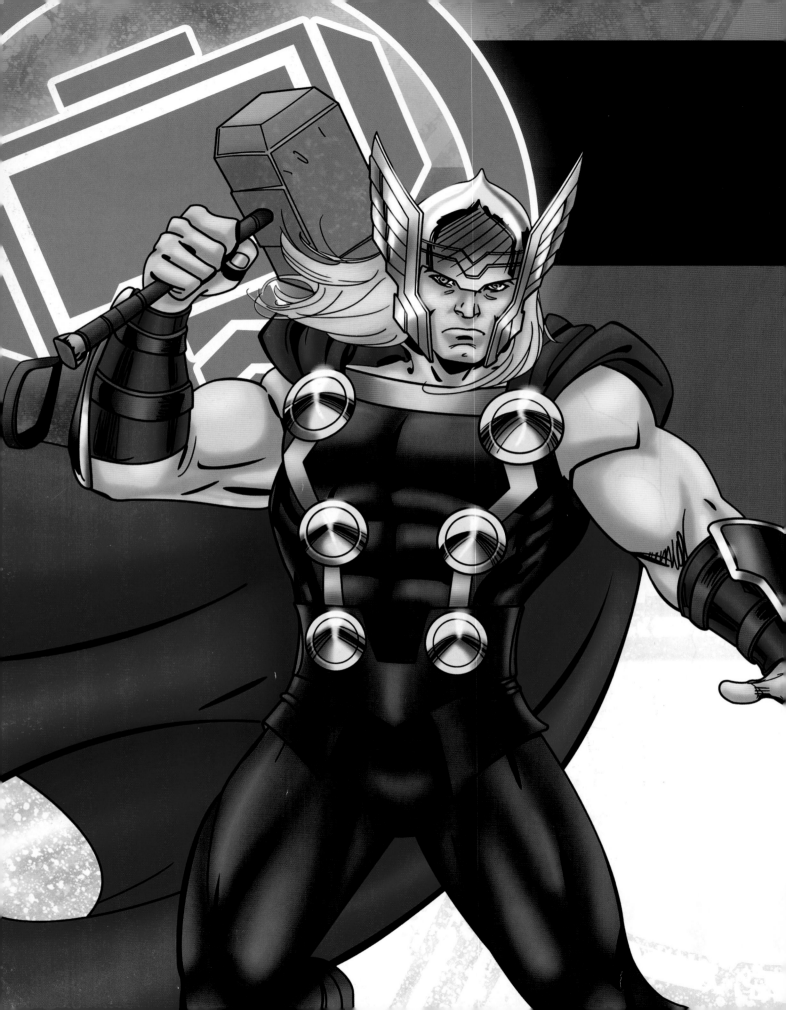

THOR

BIO:

As the Norse God of thunder and lightning, Thor wields the enchanted hammer Mjolnir. As the son of Odin and Gaea, Thor's strength, endurance, and resistance to injury are greater than the vast majority of his superhuman race. Thor is smart, compassionate, self-assured, and would never stop fighting for a worthwhile cause.

REAL NAME:
Thor Odinson

HEIGHT:
6'6"

WEIGHT:
640 lbs.

POWERS & ABILITIES:

• Is extremely long-lived, immune to conventional disease, and highly resistant to injury

• Wields the virtually unbreakable Mjolnir, a powerful hammer forged from Uru metal that allows Thor to send blasts so powerful that they can slay even immortals; the hammer cannot be used by anyone unworthy

• Can fly using Mjolnir

• Possesses the Belt of Strength and a pair of iron gauntlets to protect him when unleashing Mjolnir's most powerful energies

Follow along, first drawing basic shapes with light pencil lines. Copy the new lines shown in each step, eventually darkening the lines you want to keep and erasing the rest. Finally, add color to your drawing.

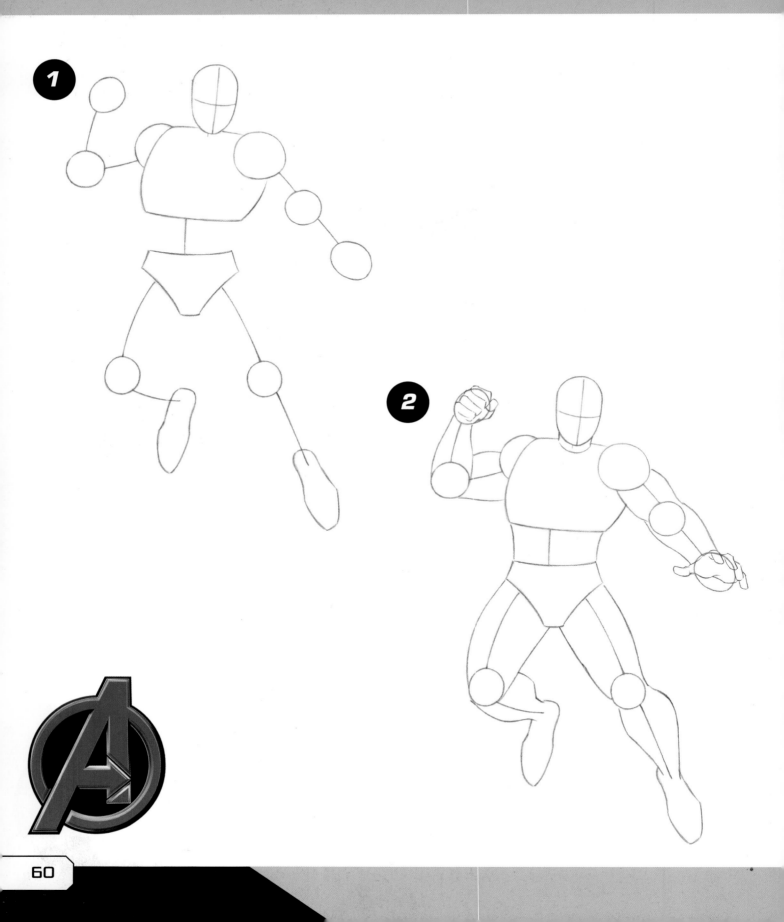

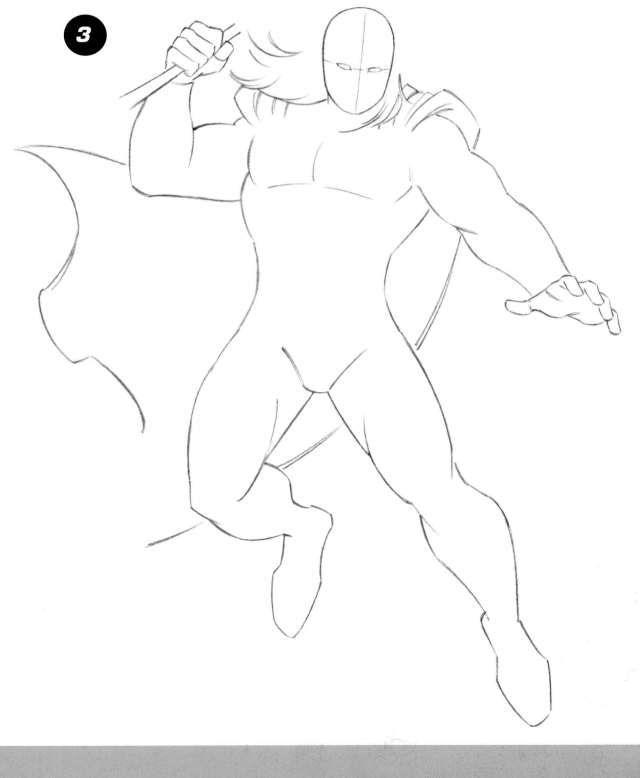

3

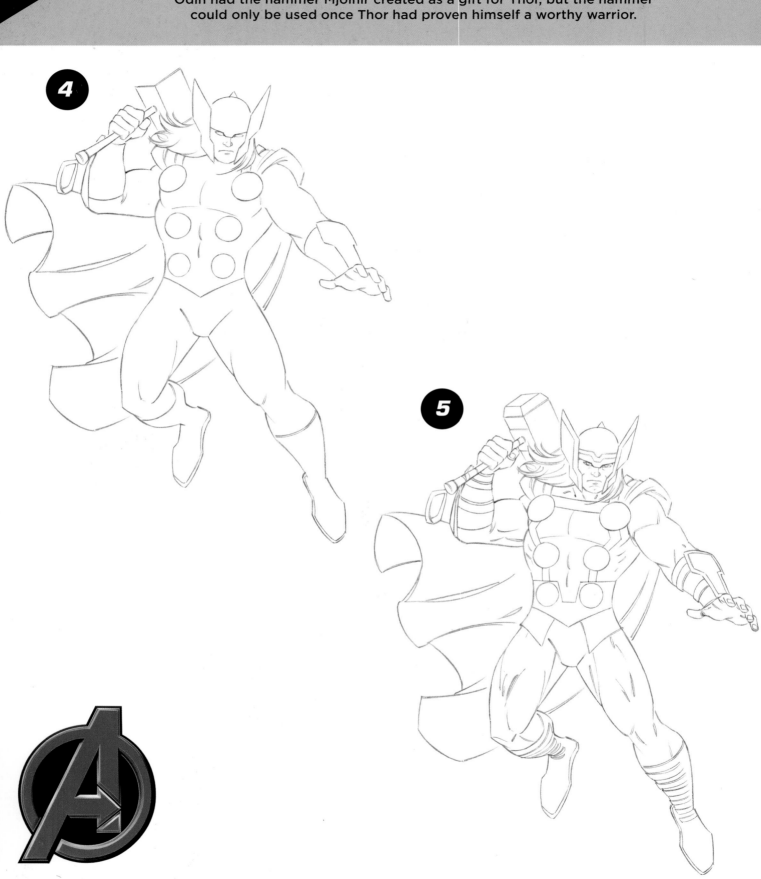

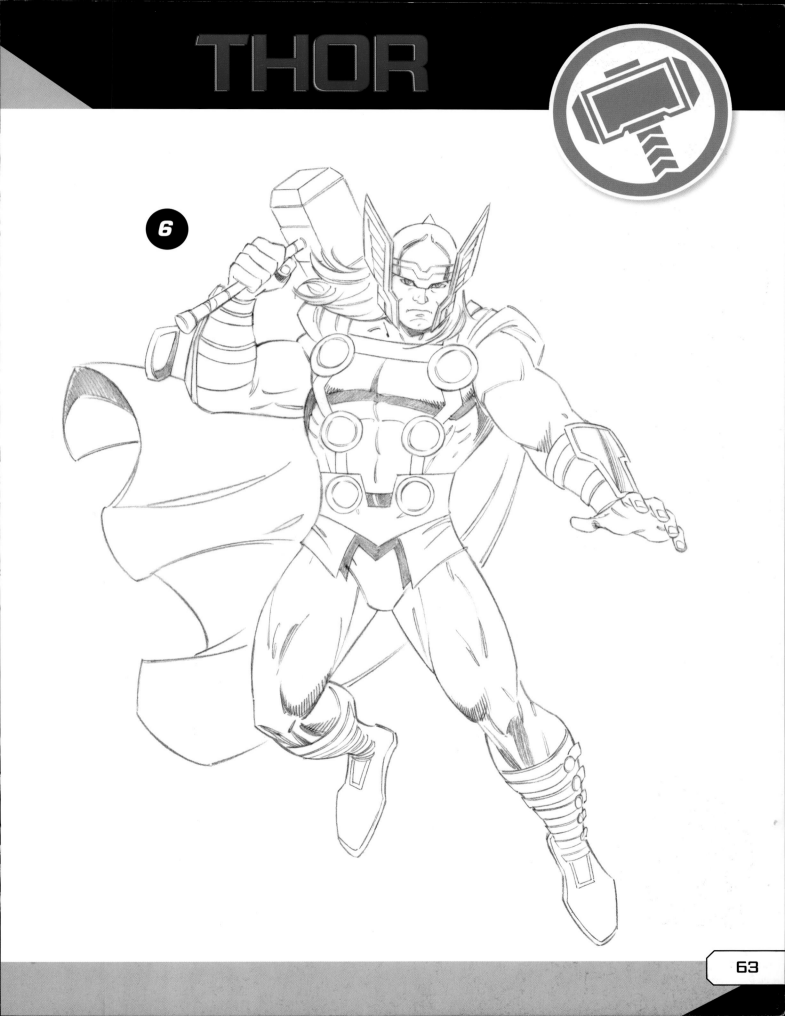

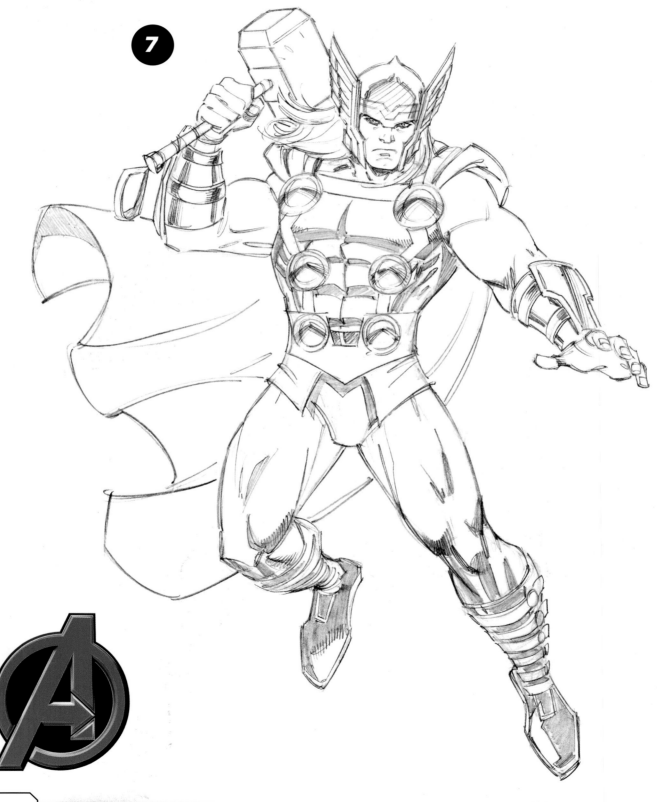

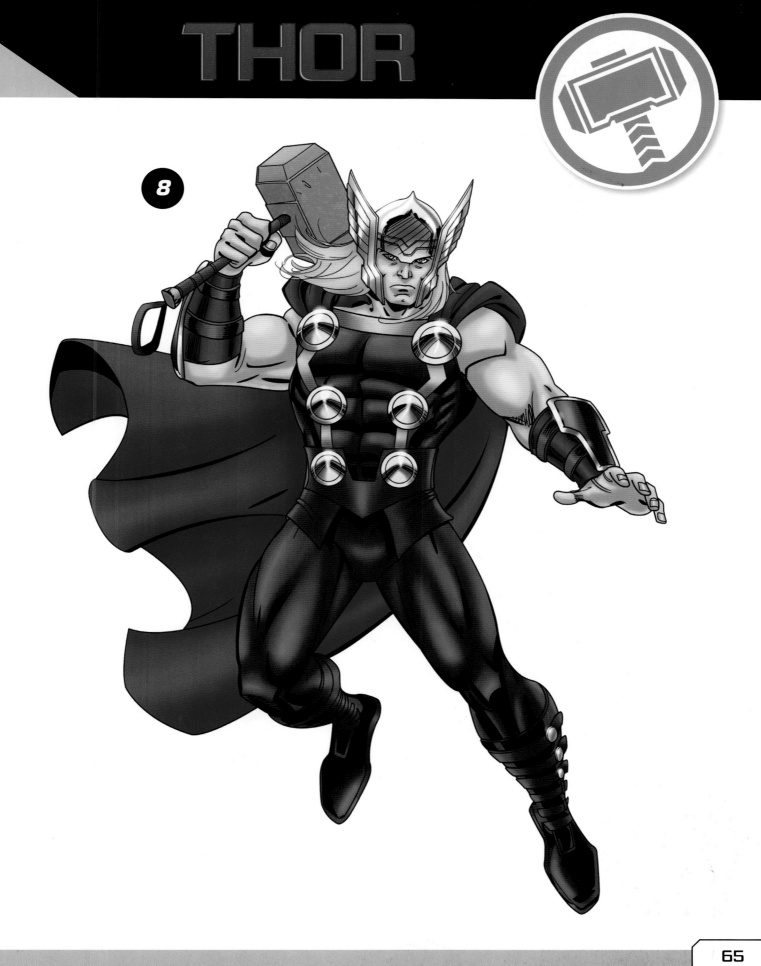

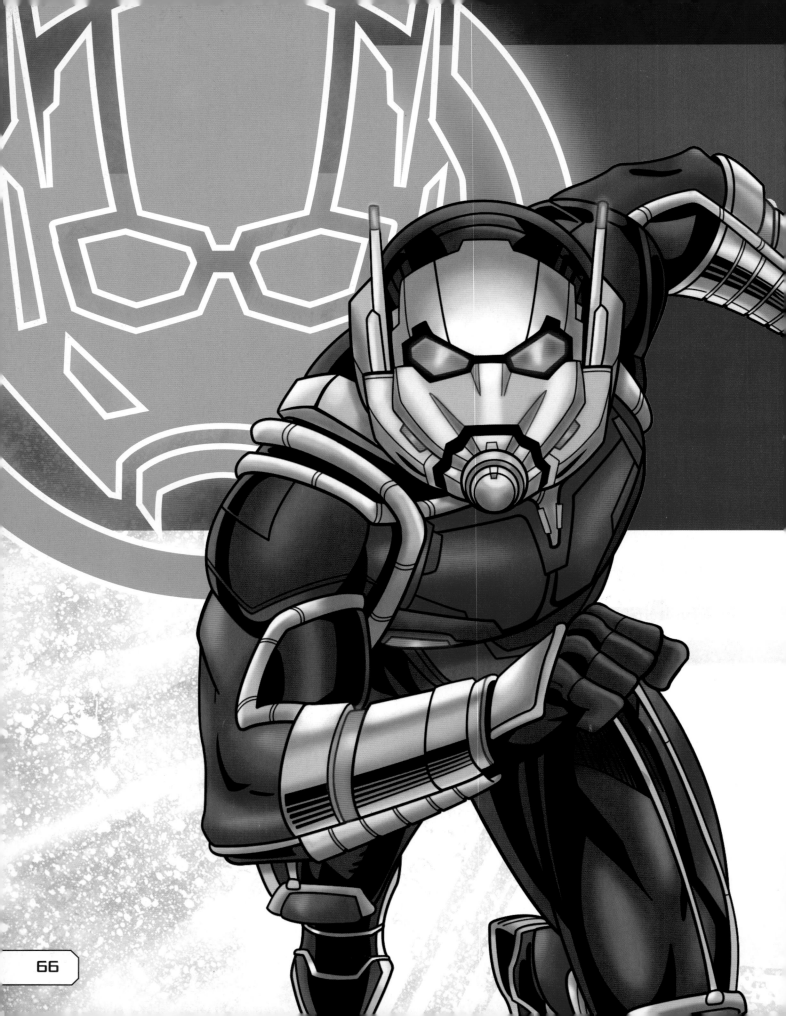

ANT-MAN

BIO:

Scott Lang, a former electronics engineer who turned to a life of crime, stole Dr. Henry Pym's Ant-Man suit, which Pym allowed him to keep. Lang became Ant-Man, able to shrink to roughly the size of an ant but still throw a punch with as much force as a normal-sized person.

REAL NAME:
Scott Lang

HEIGHT:
6'0" / nearly microscopic as Ant-Man and to 100 feet as Giant-Man

WEIGHT:
180 lbs.

POWERS & ABILITIES:

• Shrinks to the size of an ant and grows to more than 100 feet tall as Giant-Man

• Has expertise in electronics

• Possesses a helmet which is used to communicate with insects and amplify his voice so that a normal-sized person can hear him

• Wears wrist gauntlets, which enable him to shoot bioelectric blasts

Follow along, first drawing basic shapes with light pencil lines. Copy the new lines shown in each step, eventually darkening the lines you want to keep and erasing the rest. Finally, add color to your drawing.

1

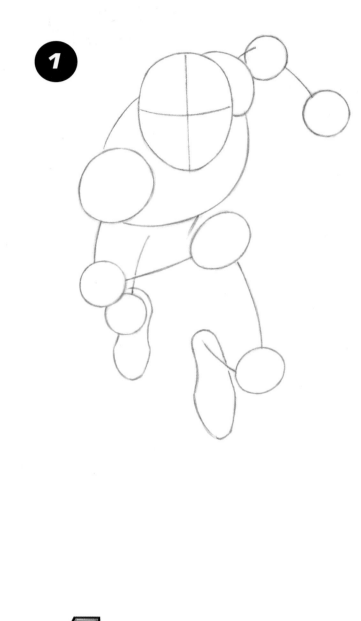

2

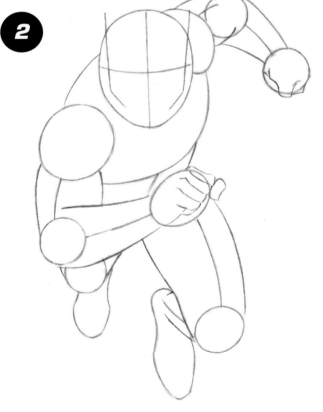

ANT-MAN

3

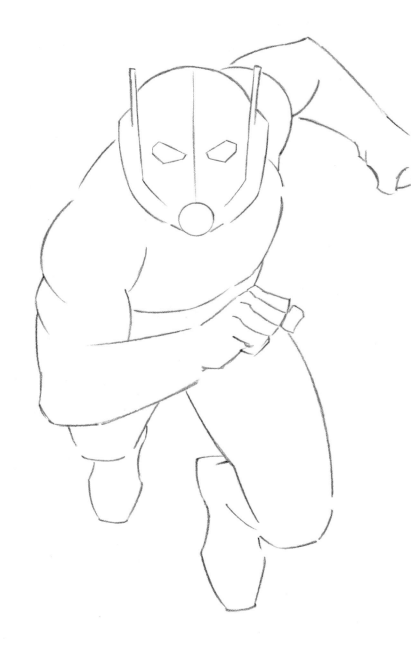

Scott Lang became a costumed Super Hero in order to provide for his beloved daughter, Cassie. For a time he even worked with Luke Cage's Heroes for Hire.

4

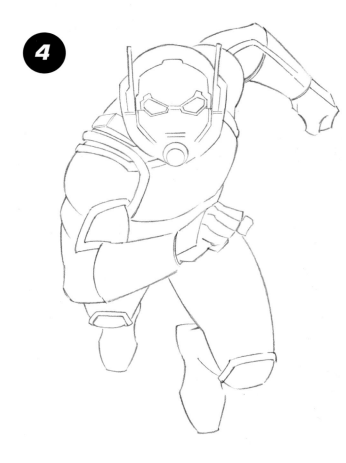

5

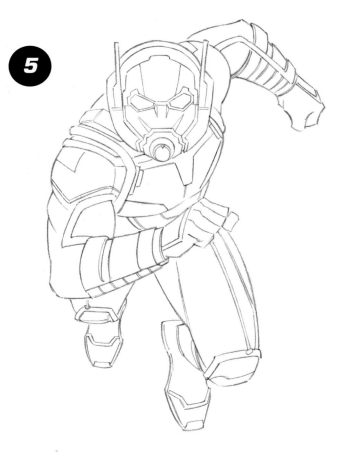

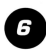

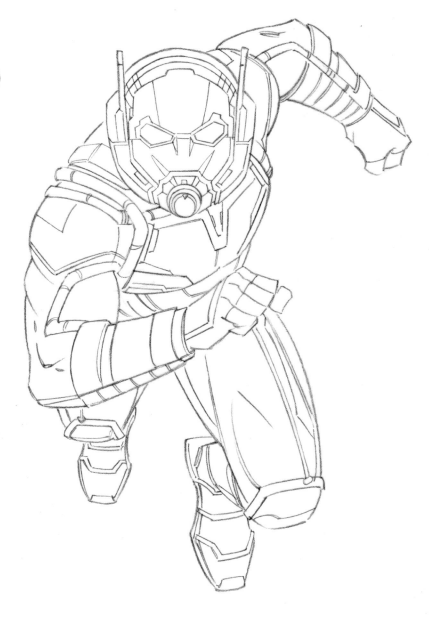

Scott Lang's size-changing abilities come from the suit created by Hank Pym, who fought as Ant-Man for years before Scott came to use the suit.

7

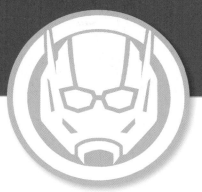

8

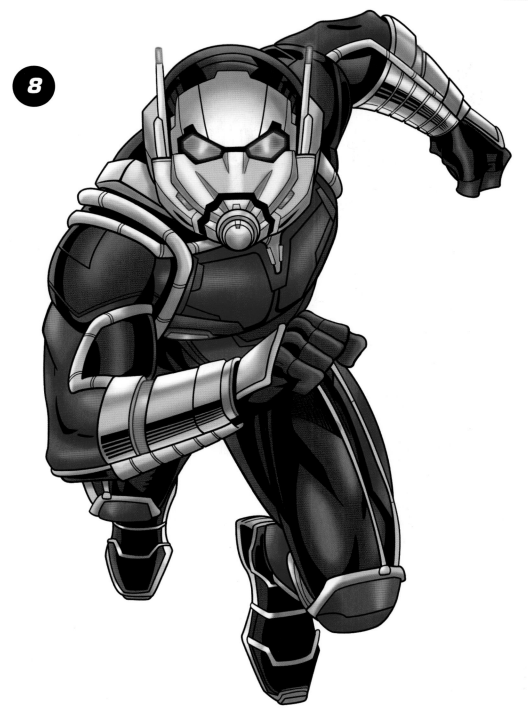

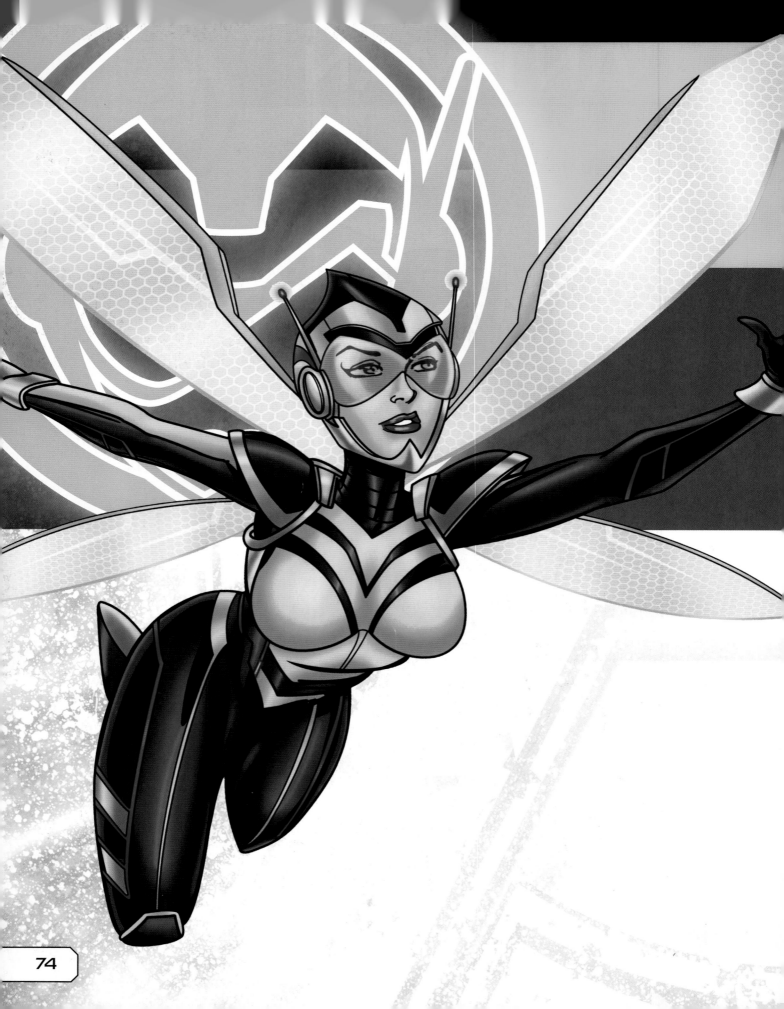

THE WASP

BIO:

Hope Van Dyne is an intelligent and successful businesswoman, as well as expert martial artist. The daughter of the original Ant-Man and Wasp, Hope uses a suit based on her mother's to become the second-generation Wasp. She battles evil on any scale, proving that true heroism comes in even the smallest sizes.

REAL NAME:
Hope Van Dyne

HEIGHT:
5'4" / Roughly the size of an insect as Wasp

WEIGHT:
110 lbs.

POWERS & ABILITIES:

• Flies at high speeds while in her shrunken state using her insect-like wings

• Shrinks is size while retaining her full strength

• Can fire blasts of energy, which she calls her "wasp's stings"

Follow along, first drawing basic shapes with light pencil lines. Copy the new lines shown in each step, eventually darkening the lines you want to keep and erasing the rest. Finally, add color to your drawing.

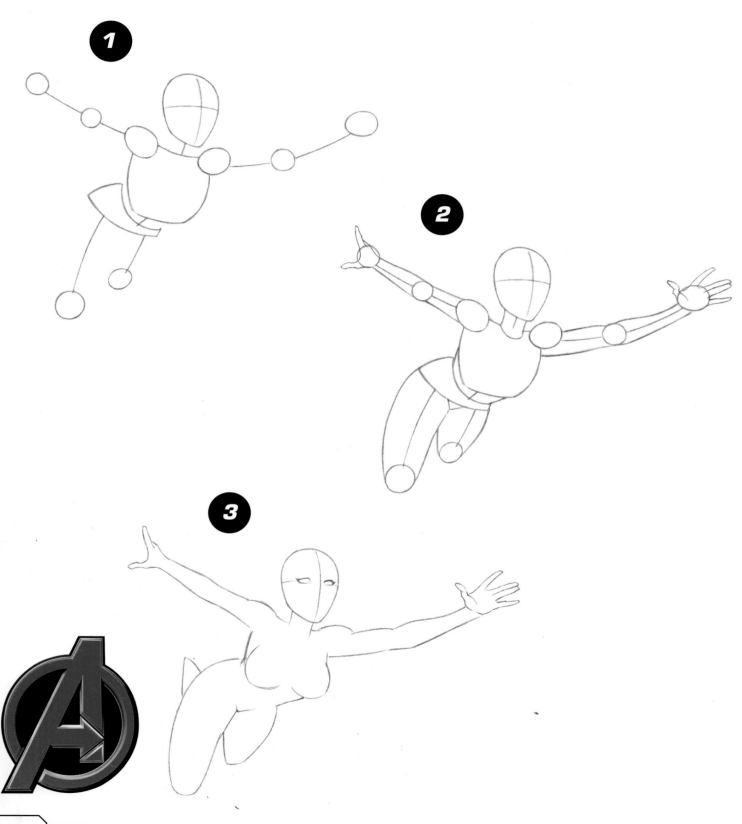

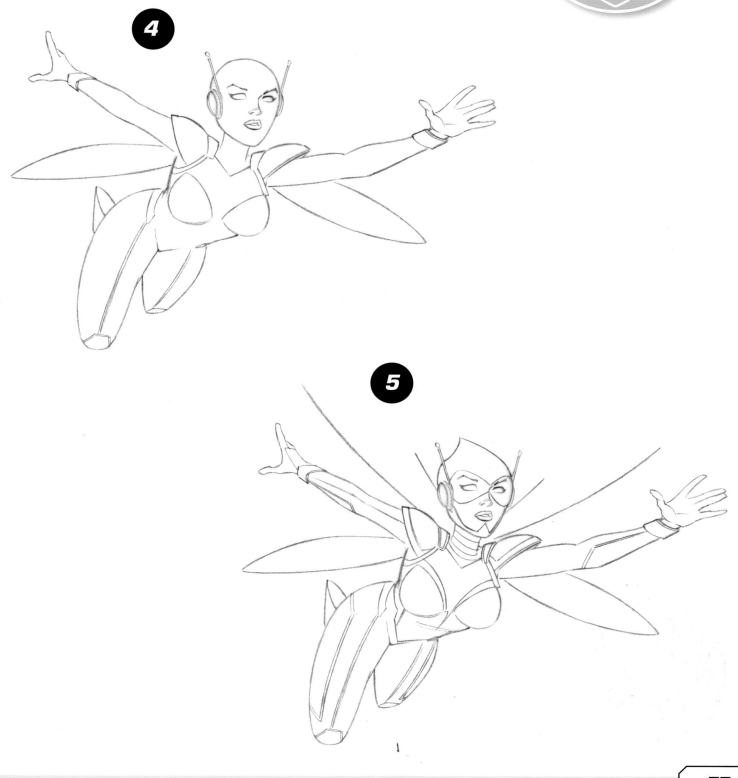

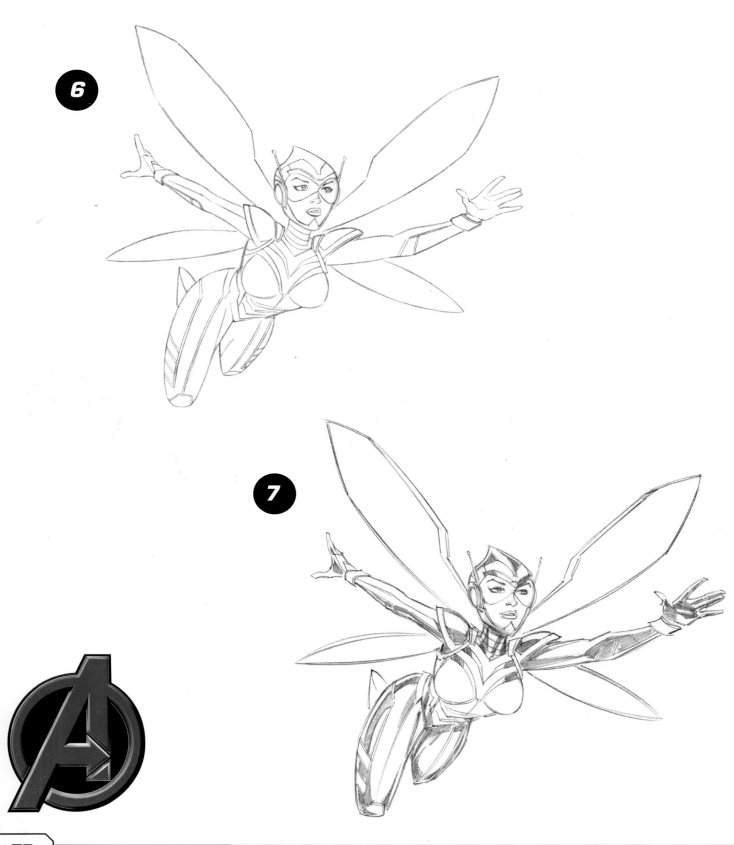

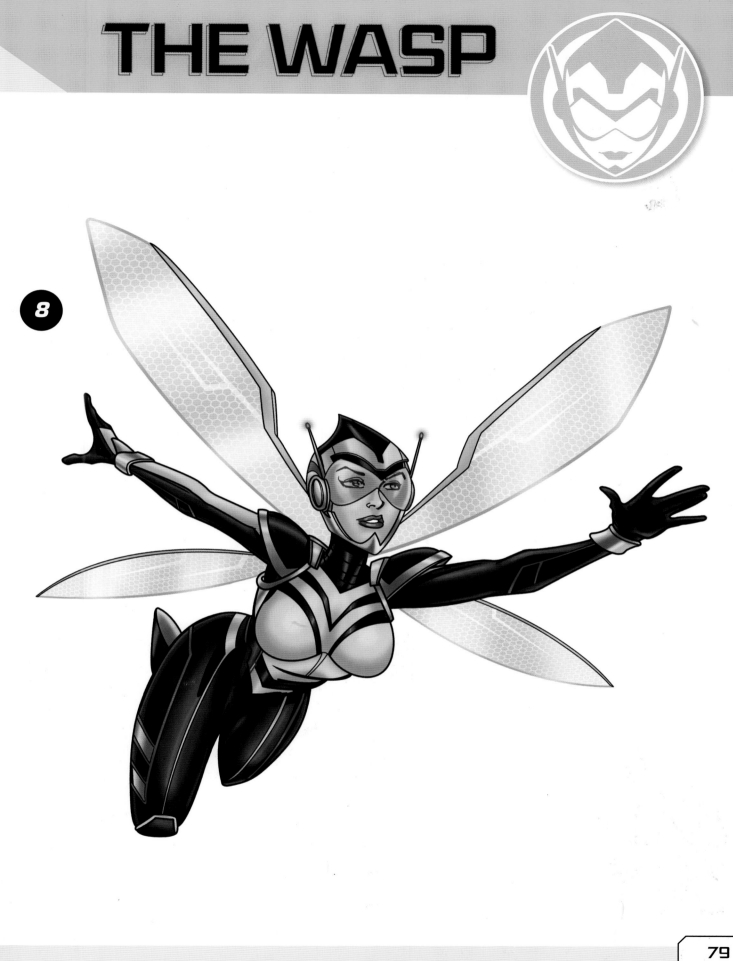

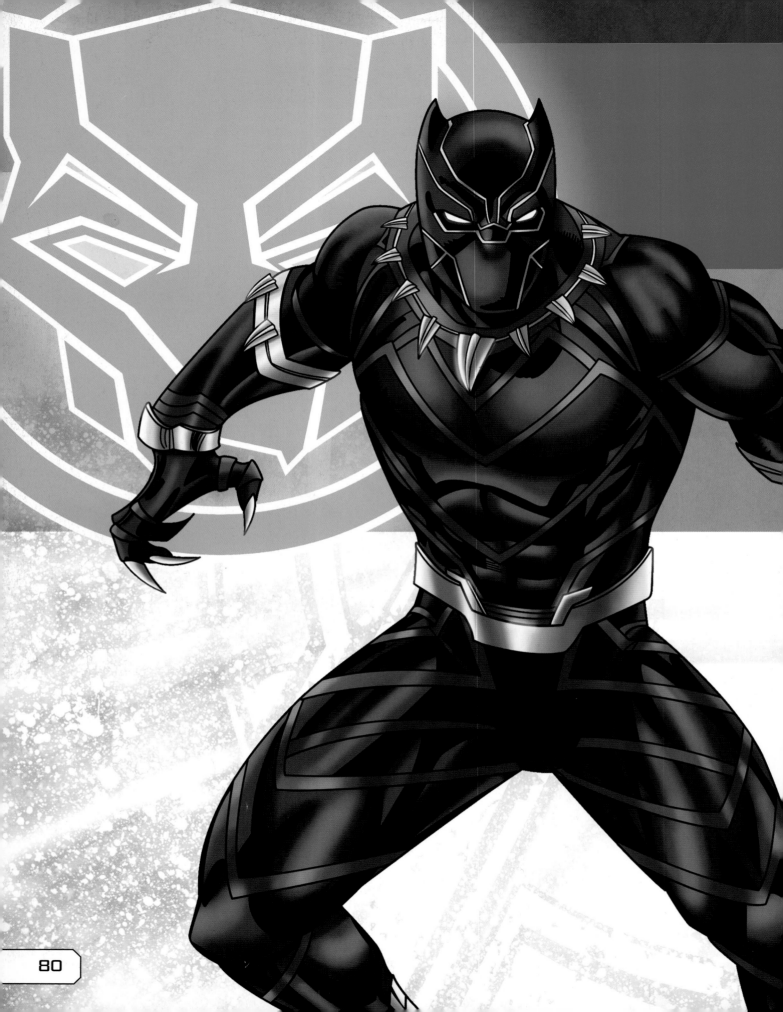

BLACK PANTHER

BIO:

While heir to the centuries-old ruling dynasty of the African kingdom Wakanda, T'Challa underwent ritual trials and consumed a heart-shaped herb, which enhanced his abilities and linked him spiritually to the Panther God Bast. He became Wakanda's ruler as the Black Panther.

REAL NAME:
T'Challa

HEIGHT:
6'0"

WEIGHT:
195 lbs.

POWERS & ABILITIES:

• Has enhanced senses and physical attributes due to the heart-shaped herb

• Is a master of unarmed and armed combat, with a unique hybrid fighting style that incorporates acrobatics and aspects of animal mimicry

• Wears a bullet-proof Vibranium-weave uniform including gloves that generate energy daggers and house anti-metal claws, as well as boots that allow him to run up the sides of buildings, land soundlessly and without injury from a height of 50 feet, walk on water, or slice through metal

• Has access to highly specialized technology, including weapons and vehicles

Follow along, first drawing basic shapes with light pencil lines. Copy the new lines shown in each step, eventually darkening the lines you want to keep and erasing the rest. Finally, add color to your drawing.

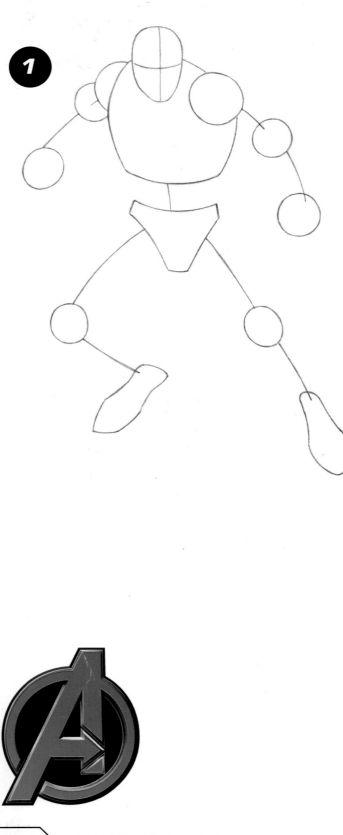

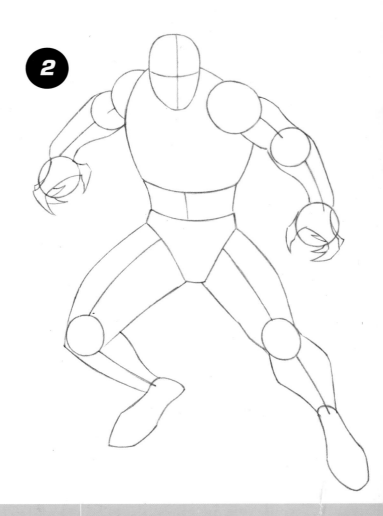

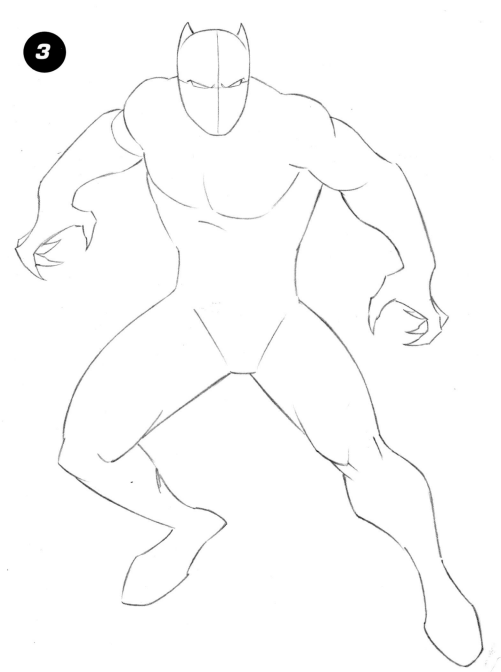

3

T'Challa originally saw the world's Super Heroes as potential threats to his country, Wakanda. Initially suspicious of the American-based Avengers, T'Challa soon saw them as true friends.

4

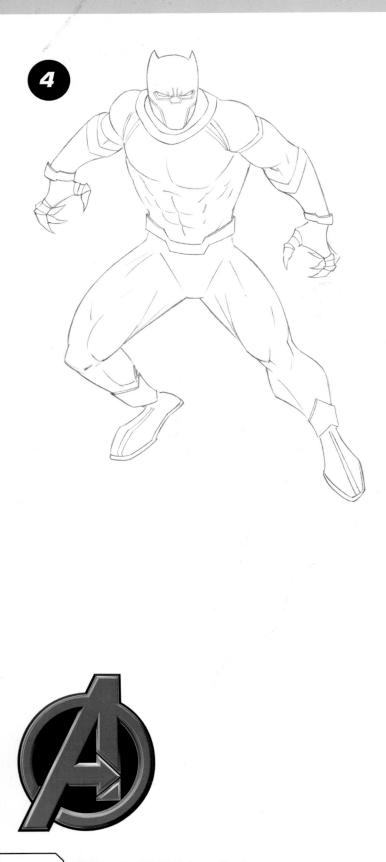

5

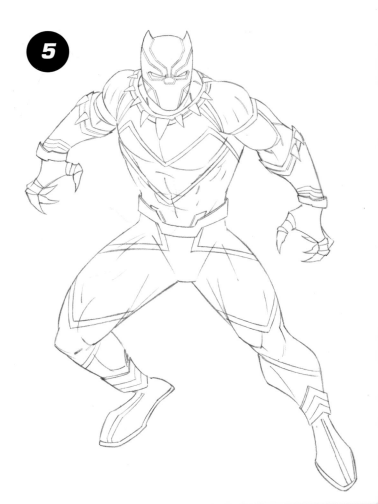

BLACK PANTHER

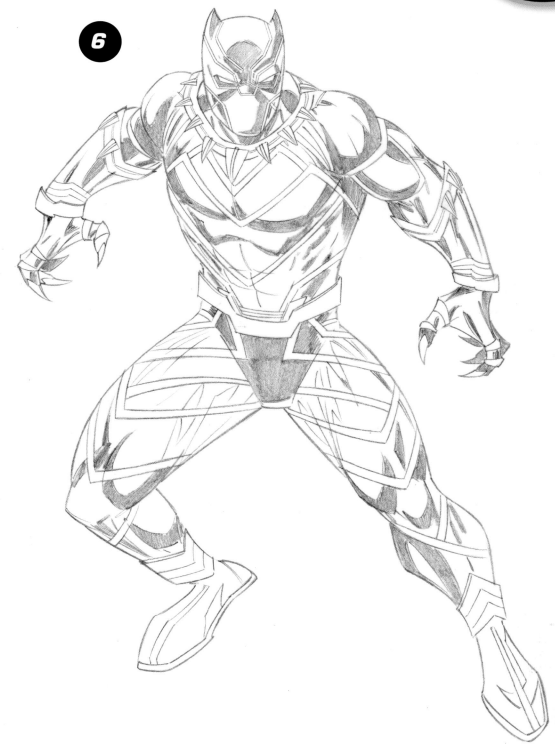

6

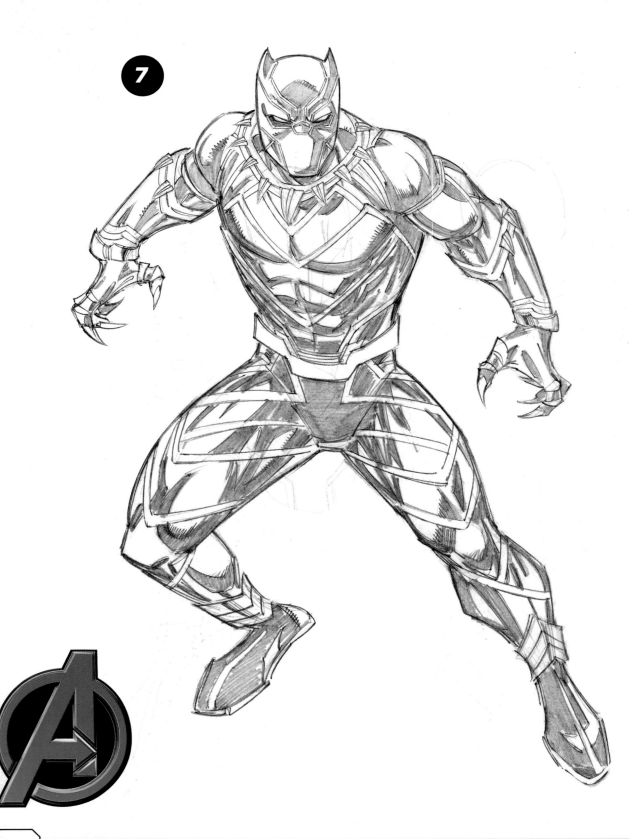

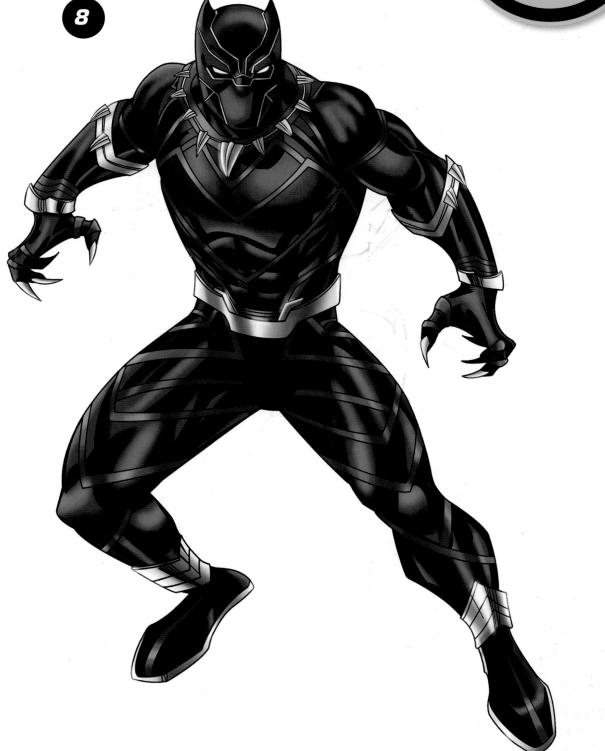

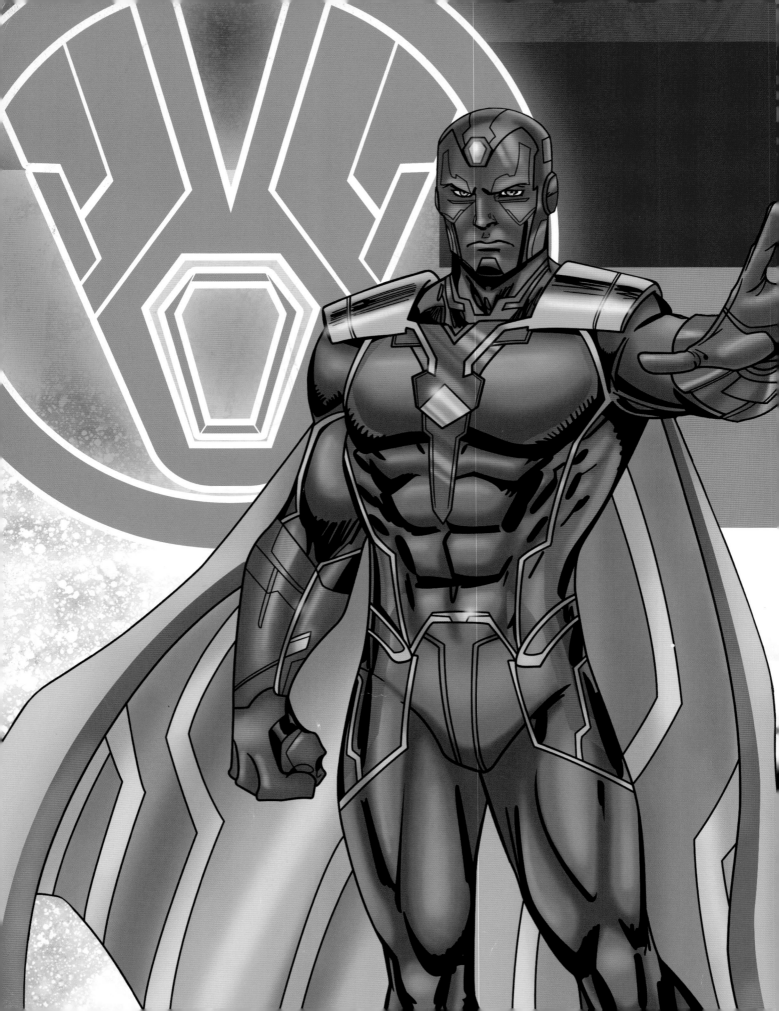

VISION

BIO:

Created by Ultron, Vision was originally meant to fight against the Avengers, not with them. He instead joined the Avengers in defeating his creator. Vision is a humanoid android controlled by the crystal in his forehead. He thinks and behaves like a human being but is completely synthetic.

REAL NAME:
Vision

HEIGHT:
6'3"

WEIGHT:
300 lbs.

POWERS & ABILITIES:

• Becomes intangible or extraordinarily dense and diamond-hard at will

• Can partially materialize within another person, causing his victim extreme pain

• Fires beams of radiation from his solar cell on his forehead

• Makes calculations with speed and accuracy

Follow along, first drawing basic shapes with light pencil lines. Copy the new lines shown in each step, eventually darkening the lines you want to keep and erasing the rest. Finally, add color to your drawing.

1

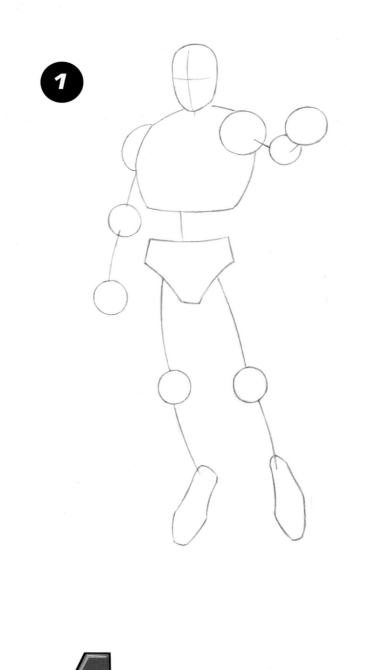

2

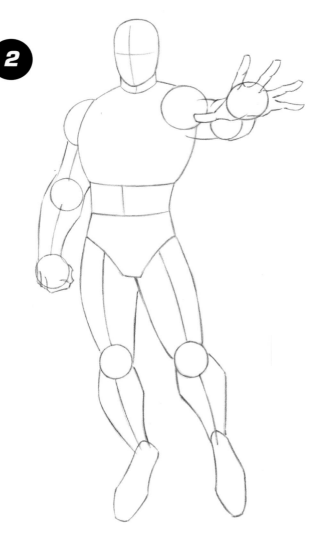

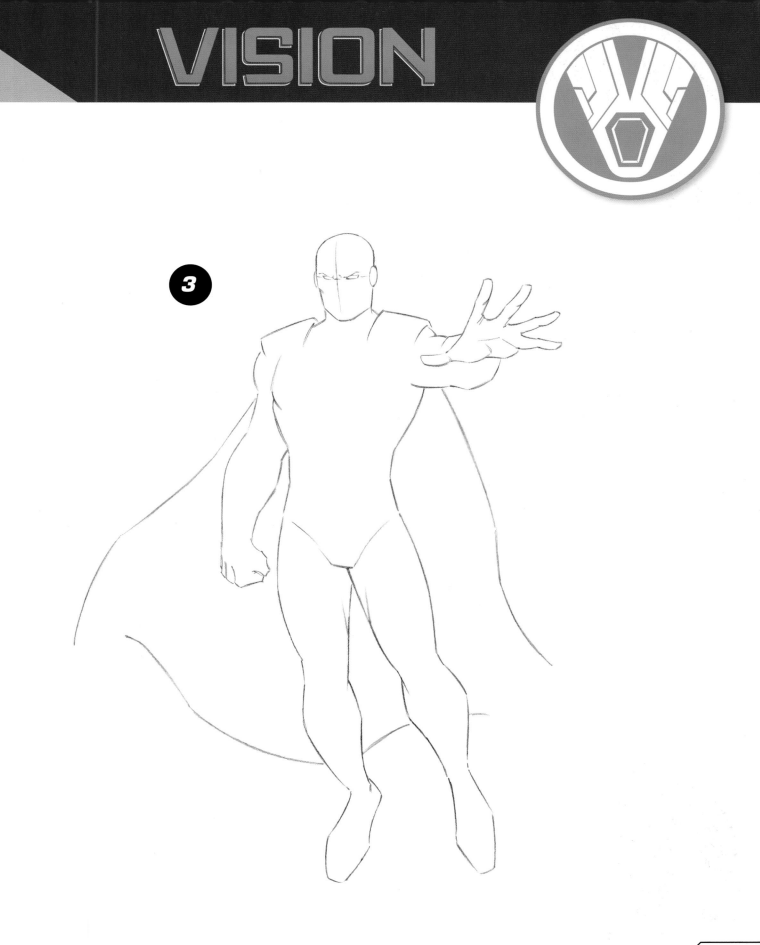

Despite being created by Ultron to fight the Avengers, Vision rebelled against
his programming and joined the Avengers to defeat his creator.

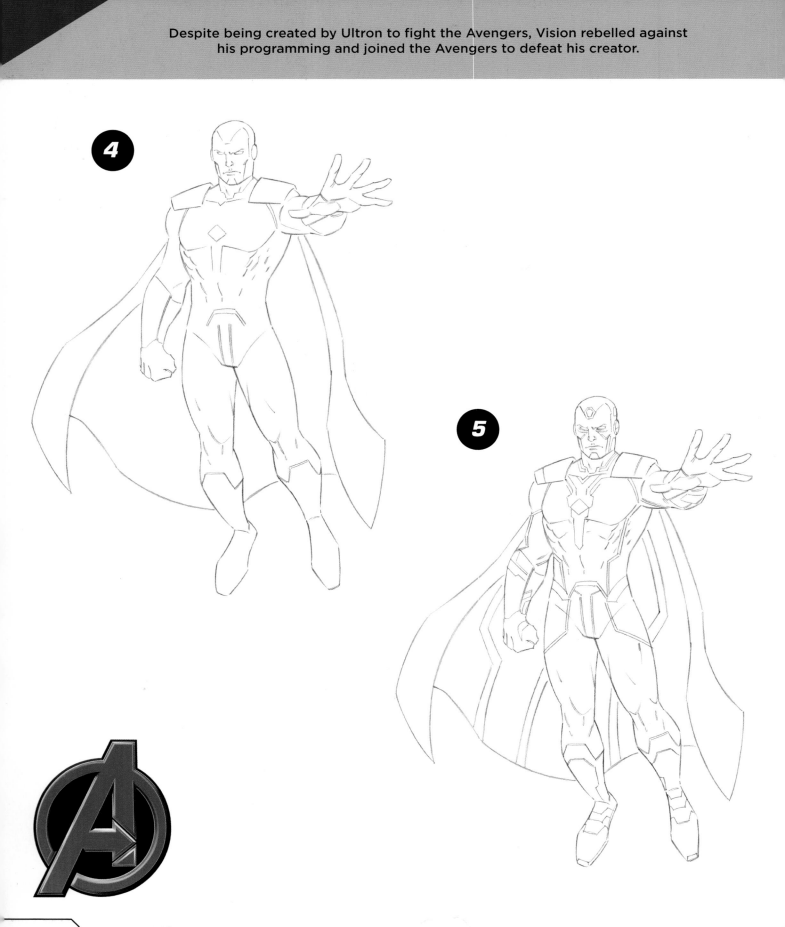

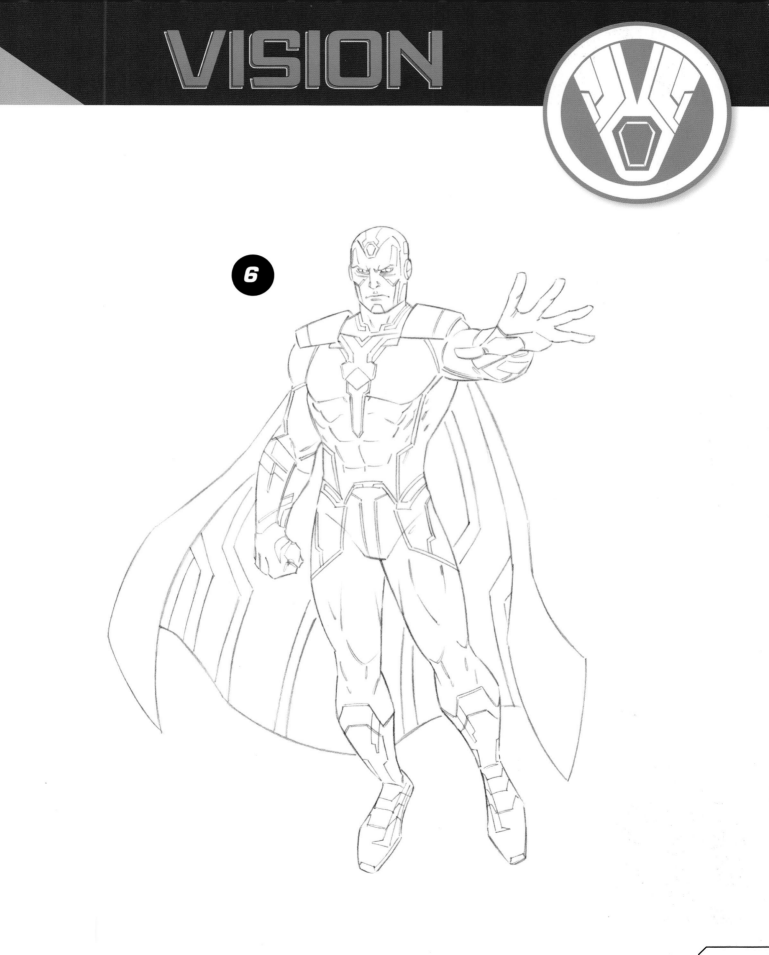

Although he is an android, the almost-human Vision developed a romantic relationship with the hex-casting heroine called the Scarlet Witch that blossomed into true love.

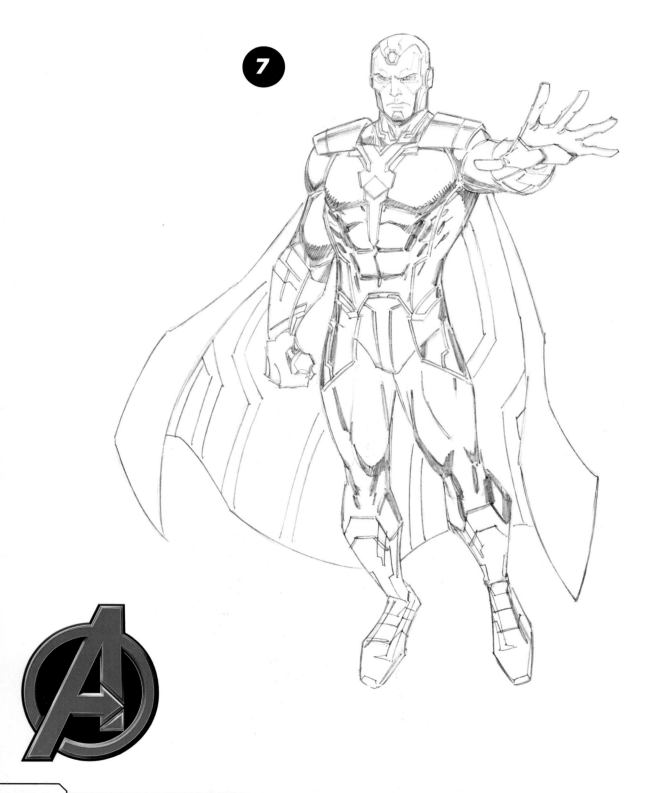

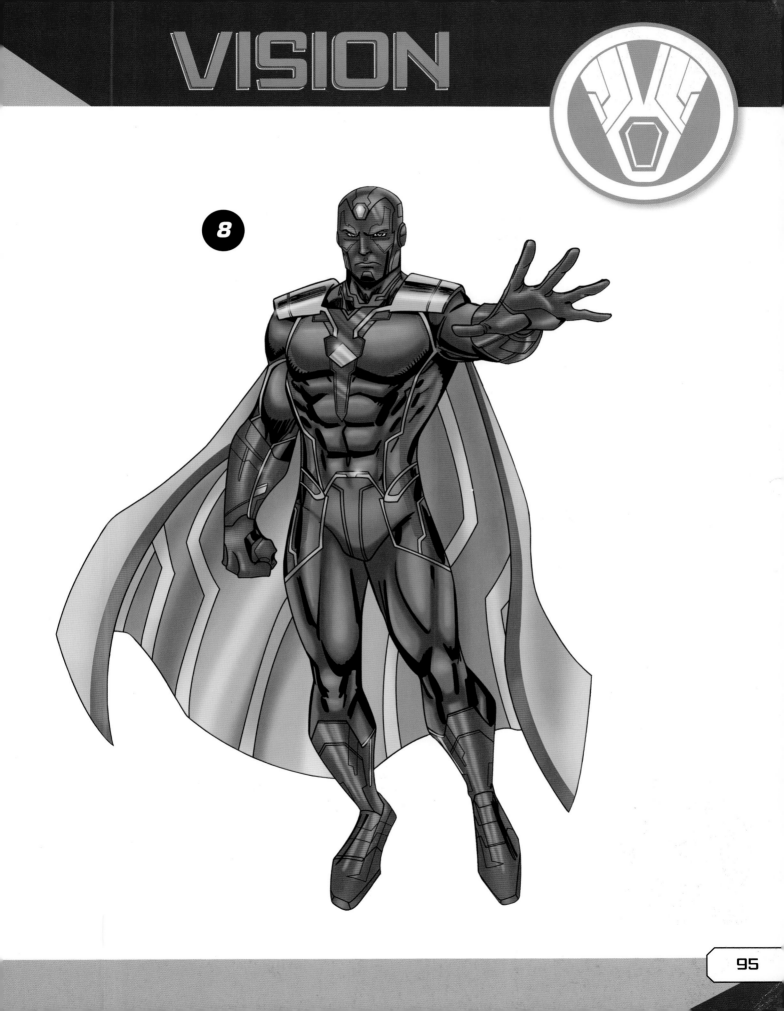

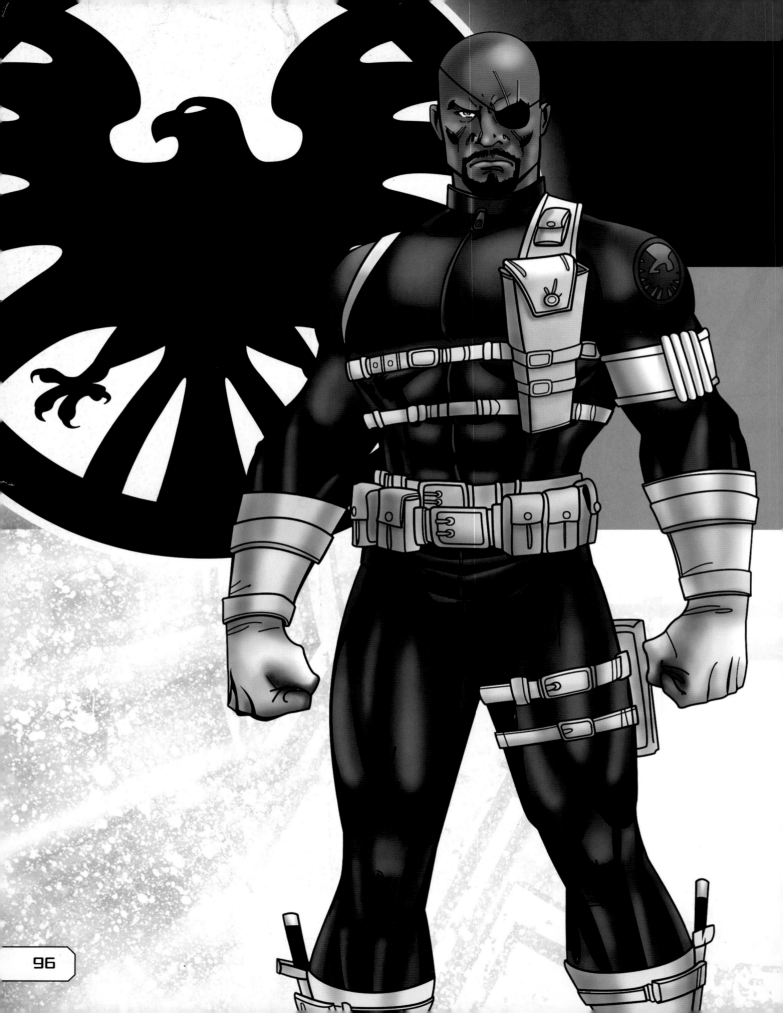

NICK FURY

BIO:

Nick Fury served as director of S.H.I.E.L.D., an international intelligence agency, after serving the United States for many years and in many different capacities. Wounded while on a mission, he is missing his left eye and must now wear an eye patch.

REAL NAME:
Nicholas Joseph "Nick" Fury

HEIGHT:
6'3"

WEIGHT:
210 lbs.

POWERS & ABILITIES:

• Can fly planes and also has a license to command ocean-going vessels

• Is seasoned in unarmed and armed combat

• Is a master in the art of espionage, covert actions, marksmanship, and military strategy

• Employs the full range of S.H.I.E.L.D.'s intelligence-gathering capabilities, as well as its most technologically advanced gadgetry and equipment

Follow along, first drawing basic shapes with light pencil lines. Copy the new lines shown in each step, eventually darkening the lines you want to keep and erasing the rest. Finally, add color to your drawing.

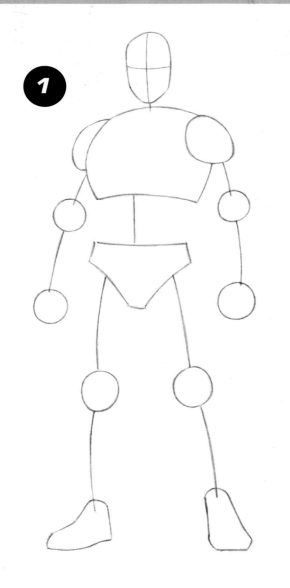

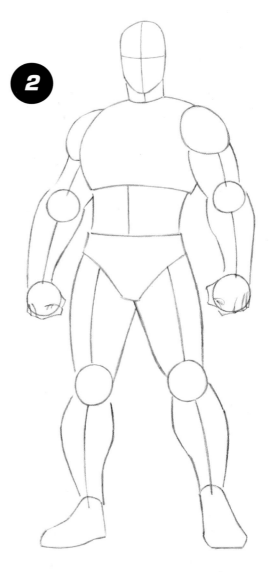

3

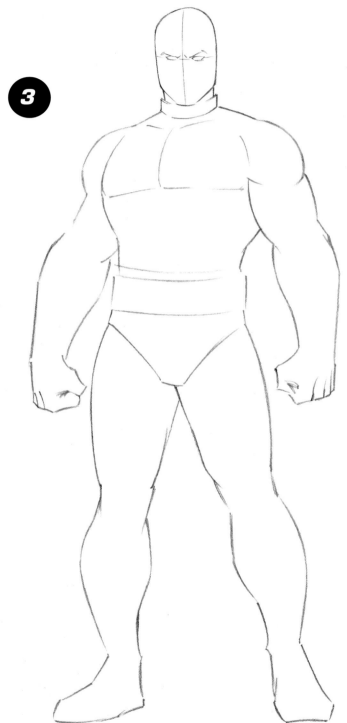

Although Nick Fury is a formidable fighter, he typically works in secret,
orchestrating events and communicating to those he can trust from the shadows.

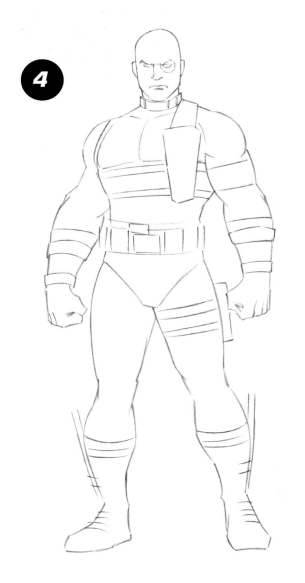

4

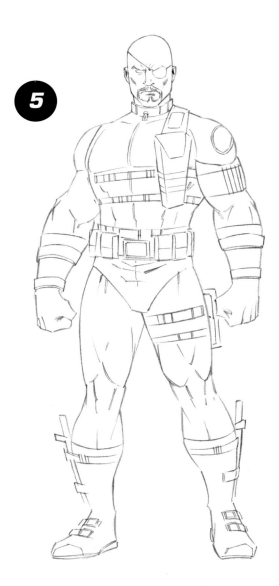

5

6

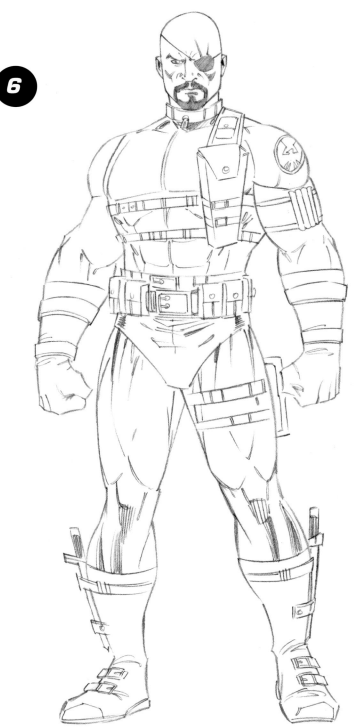

As director of S.H.I.E.L.D., Nick Fury had access to some of the most advanced technology on Earth, resulting in his high-tech weapons and uniform.

7

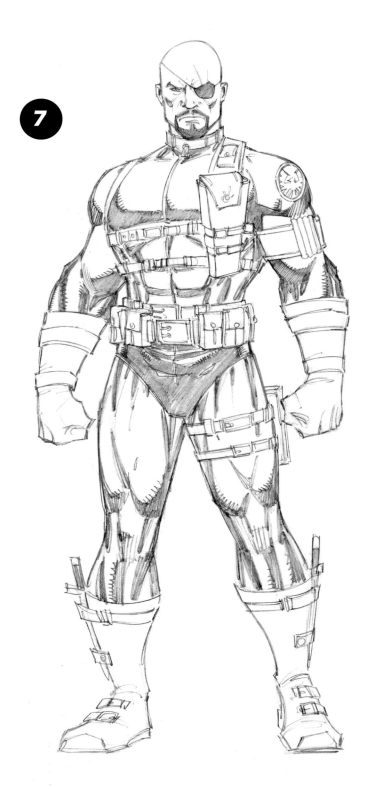

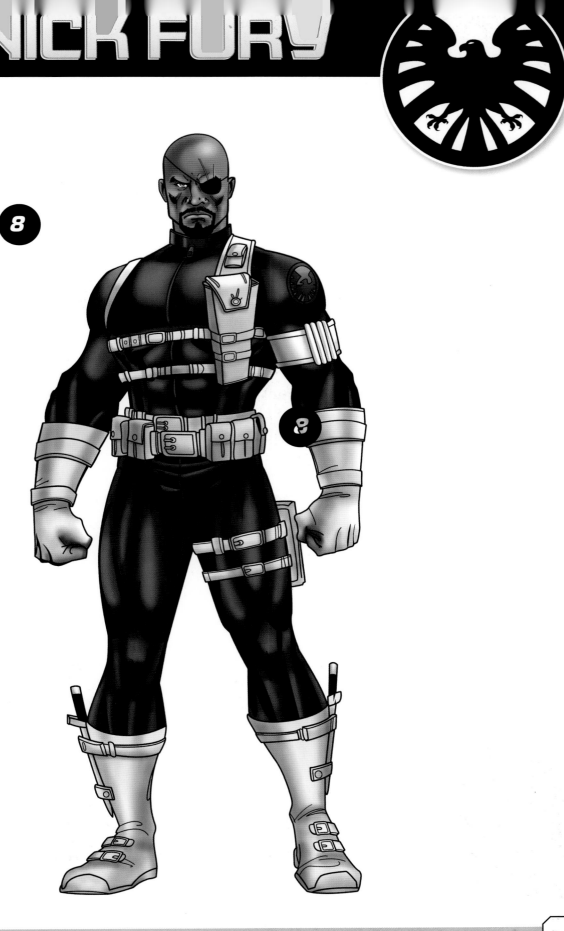

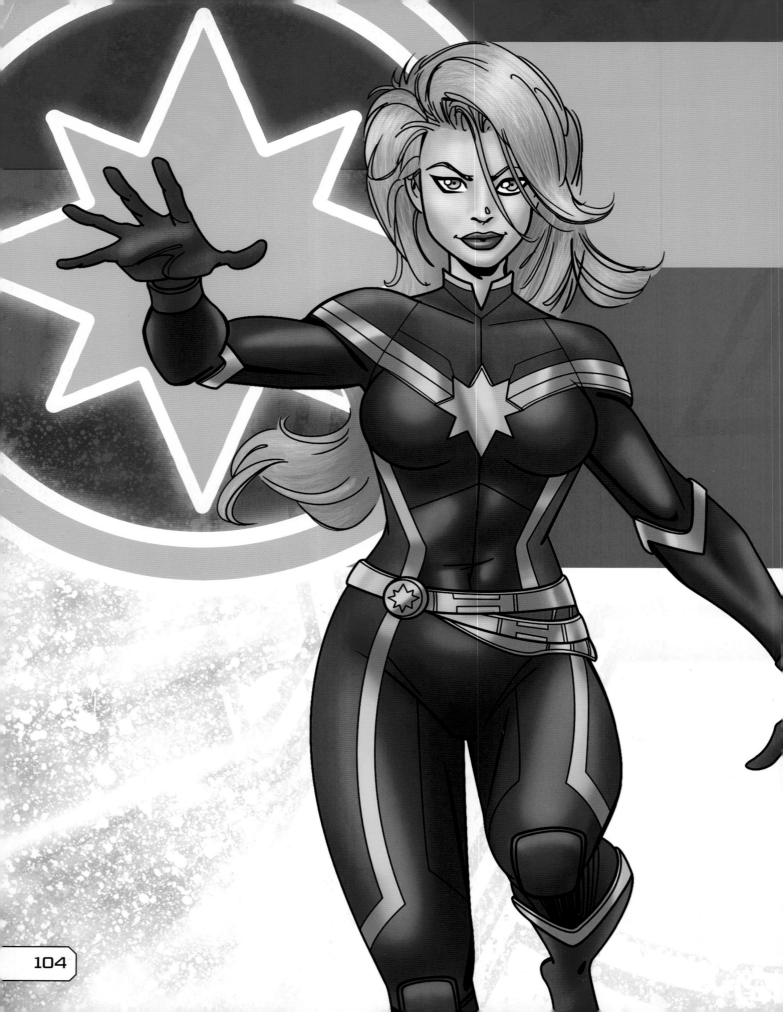

CAPTAIN MARVEL

BIO:

After graduating from high school, Carol Danvers joined the Air Force and rose to the rank of Colonel. She became Ms. Marvel after she was caught in the explosion of a Kree Psyche-Magnetron device with the Kree Mar-Vell and became a Kree-human hybrid. Carol Danvers then went to work as a writer and editor, while joining the Avengers as Ms. Marvel and later as Captain Marvel.

REAL NAME:
Carol Danvers

HEIGHT:
5'11"

WEIGHT:
124 lbs.

POWERS & ABILITIES:

- Capable of flight with or without a plane

- Has enhanced strength

- Can shoot concussive energy bursts from her hands

Follow along, first drawing basic shapes with light pencil lines. Copy the new lines shown in each step, eventually darkening the lines you want to keep and erasing the rest. Finally, add color to your drawing.

1

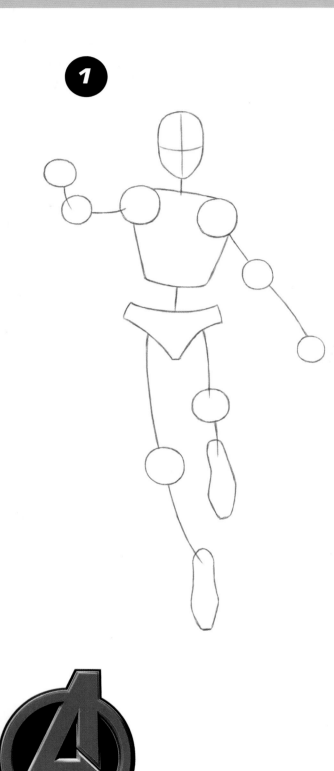

2

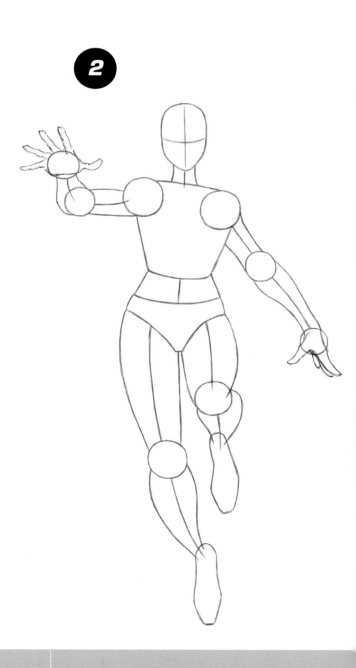

3

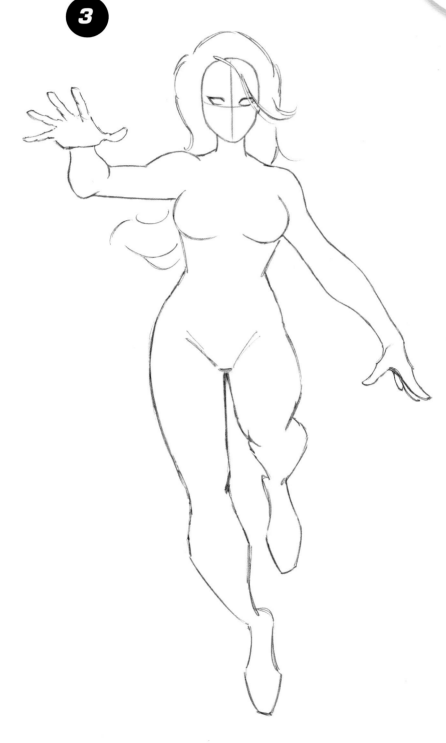

4

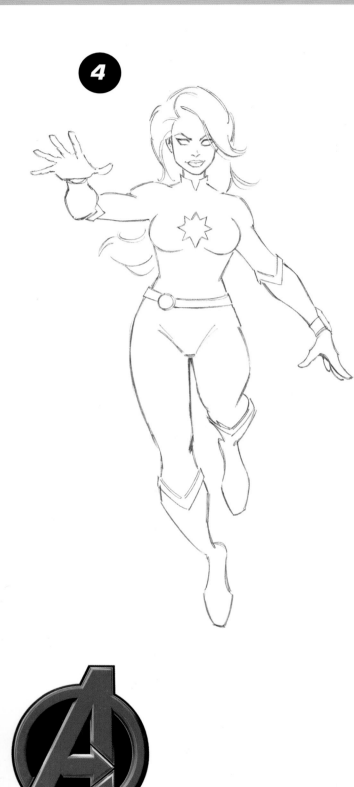

5

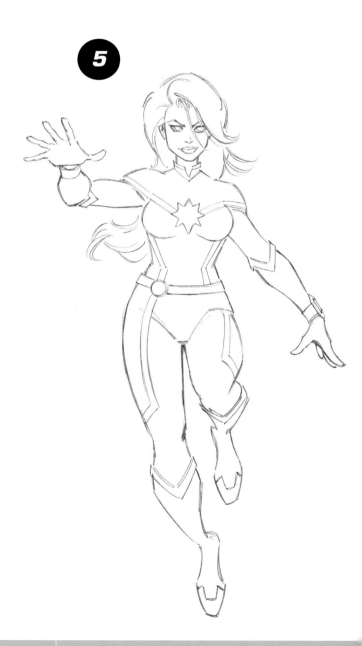

6

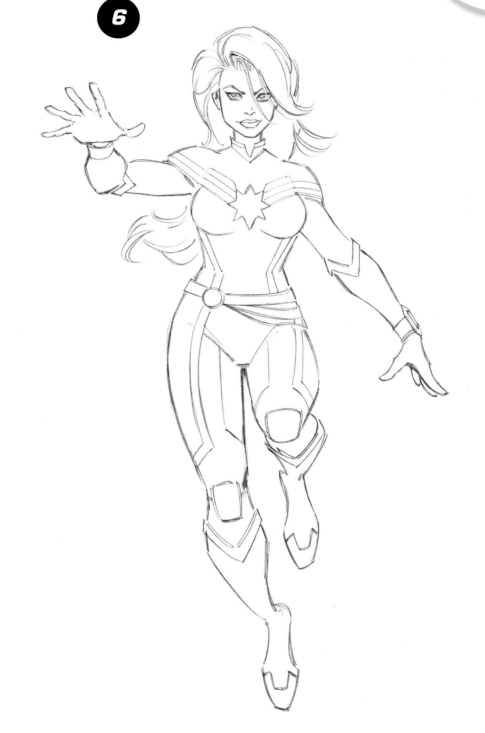

Carol was caught in the explosion of a Psyche-Magnetron device.
This resulted in Carol becoming a human-Kree hybrid and gaining super-powers.

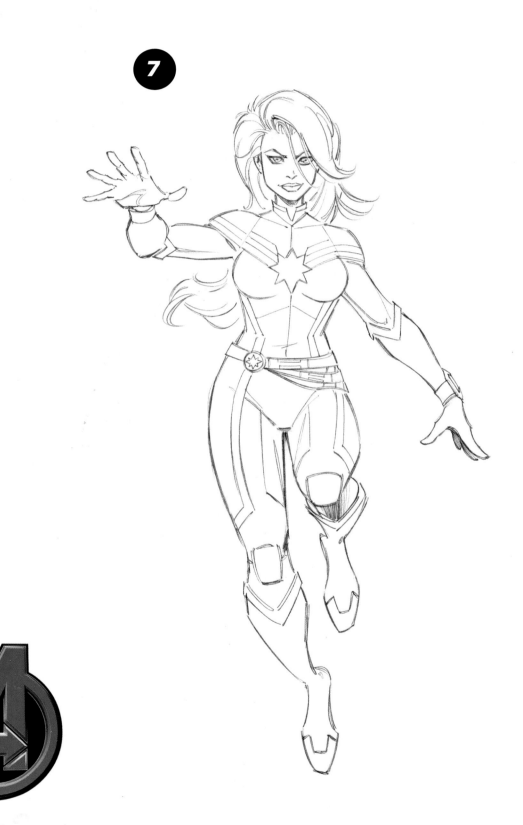

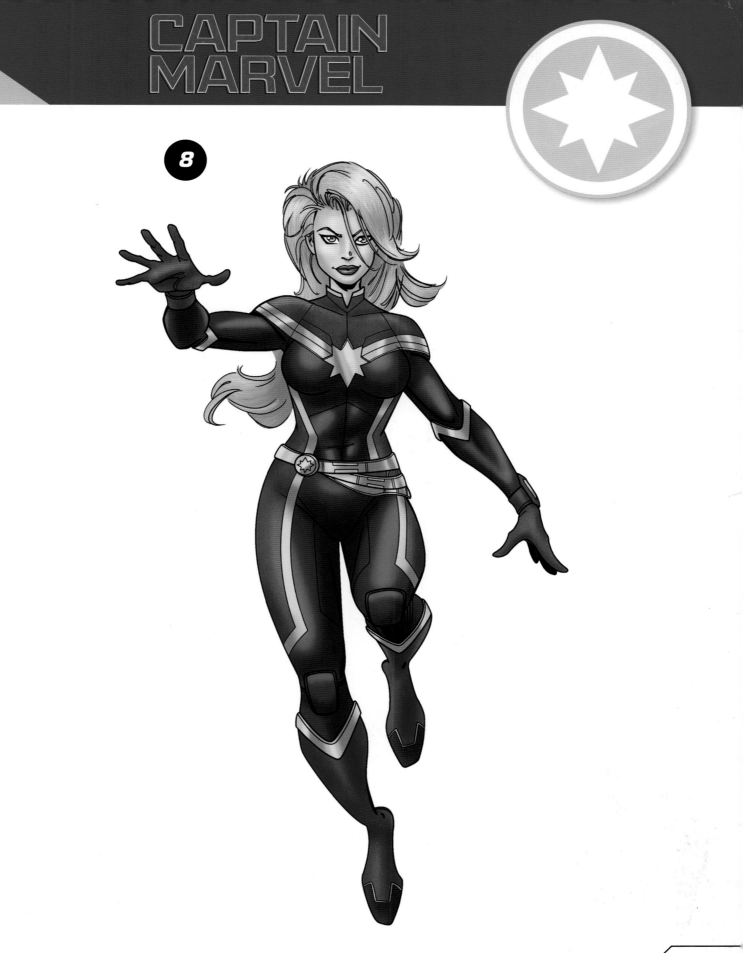

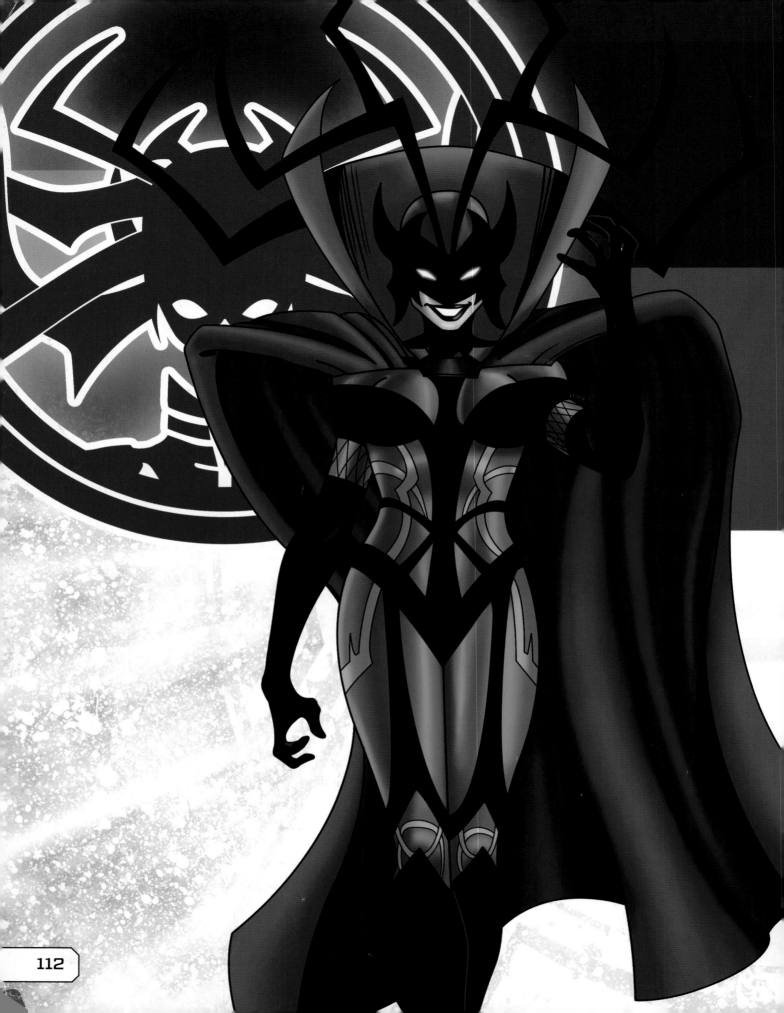

HELA

BIO:

While Odin's Valhalla palace houses all of the souls who died as heroes, the goddess Hela has dominion over the Asgardian souls who did not die in battle. Hela is ruler of Hel and Niffleheim. The left side of her body is dead and decayed but looks alive and well once she dons her cloak.

REAL NAME:
Hela

HEIGHT:
7'0"

WEIGHT:
500 lbs.

POWERS & ABILITIES:

• Draws spirits from the bodies of the dead with her touch; however, she can touch and kill healthy Asgardians if she chooses

• Is long-lived, super-strong, immune to all diseases, and resistant to conventional injury

• Has the power to restore life to recently deceased gods as long as their spirits have not left their bodies

Follow along, first drawing basic shapes with light pencil lines. Copy the new lines shown in each step, eventually darkening the lines you want to keep and erasing the rest. Finally, add color to your drawing.

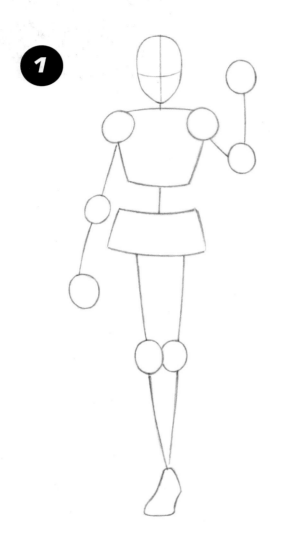

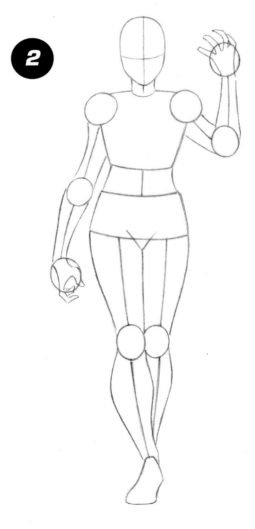

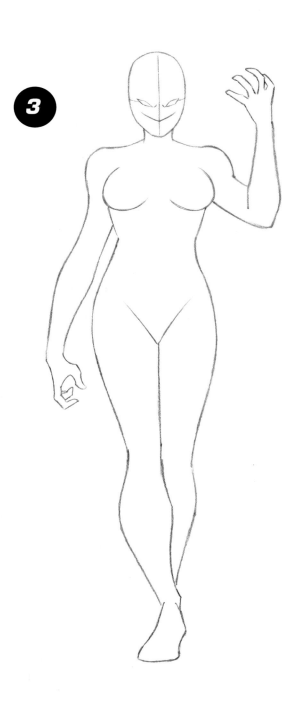

3

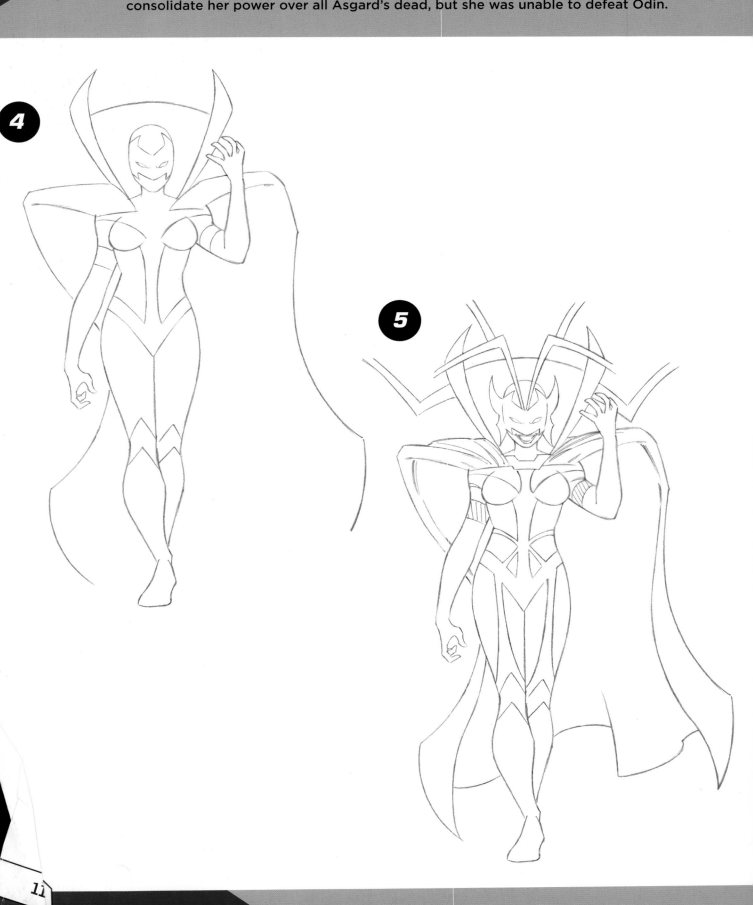

6

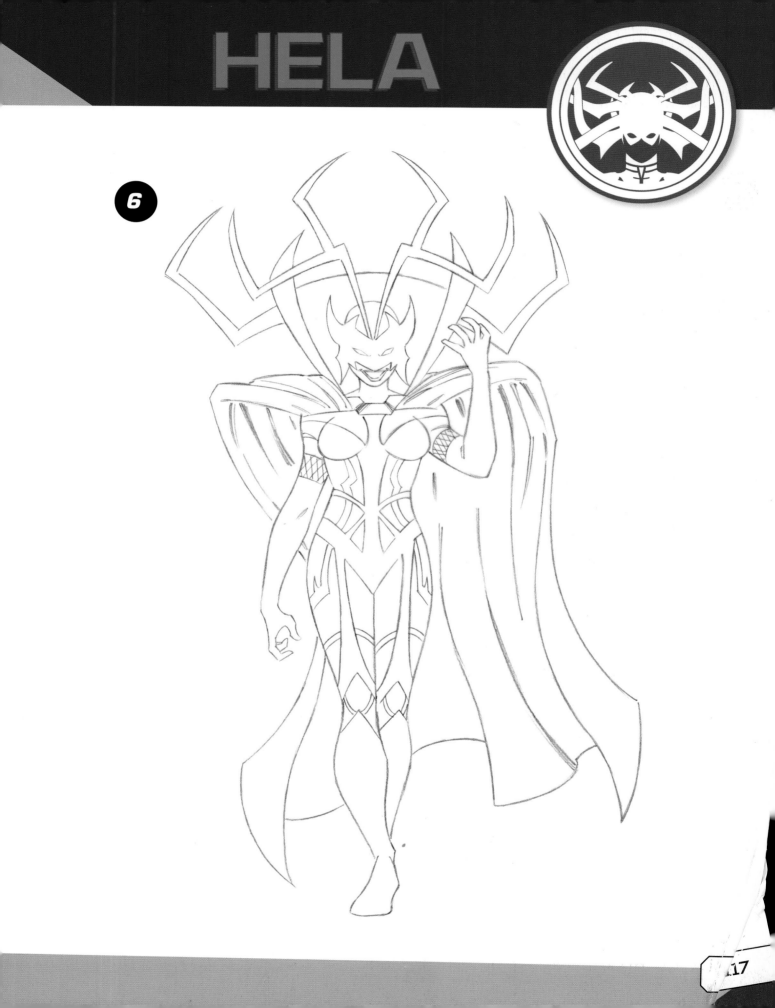

Hela is able to travel in her astral form,
possessing the same powers as she does in her physical form.

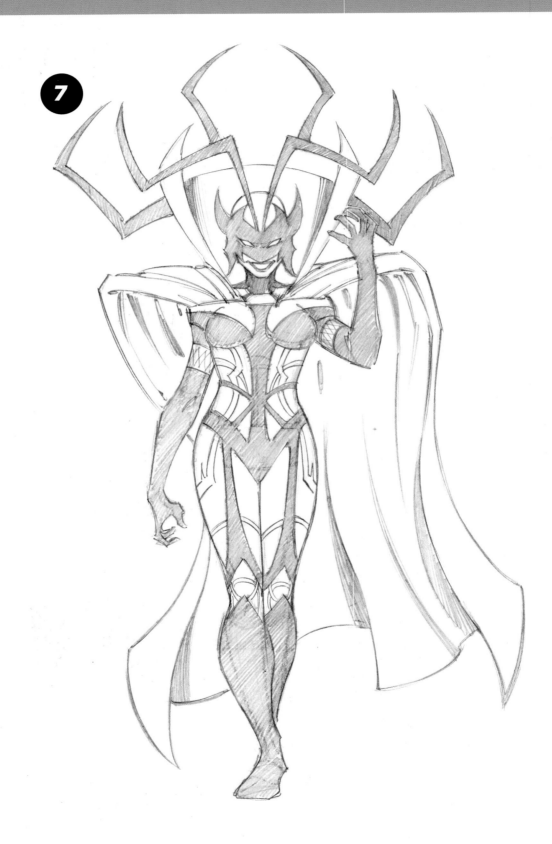

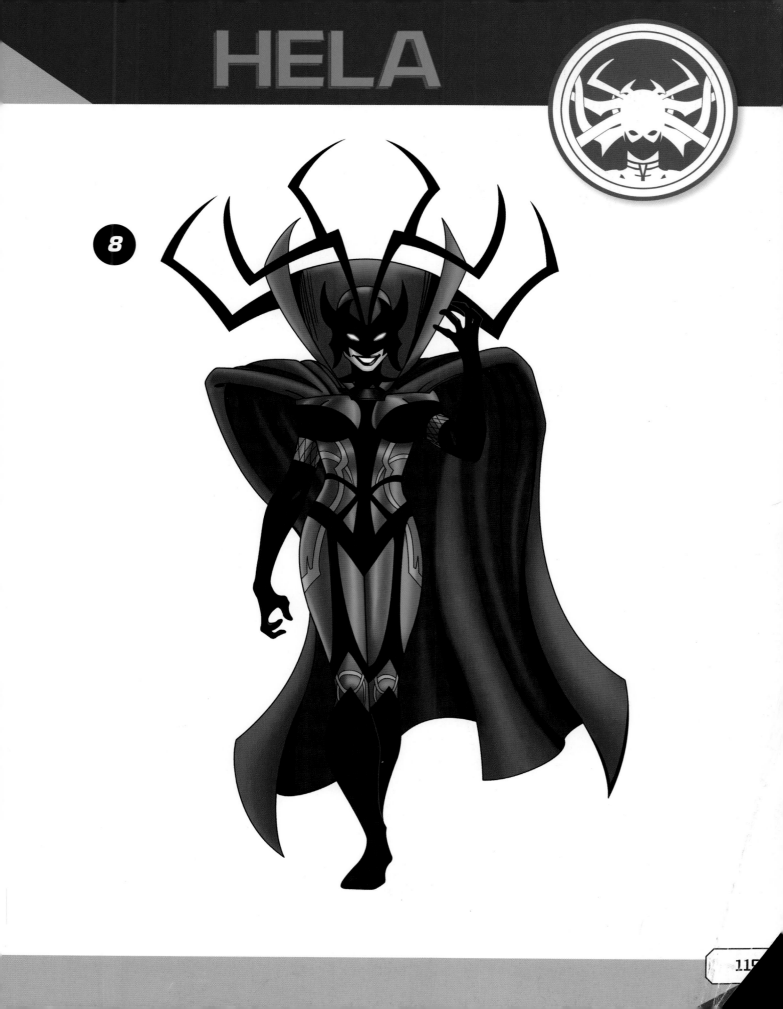

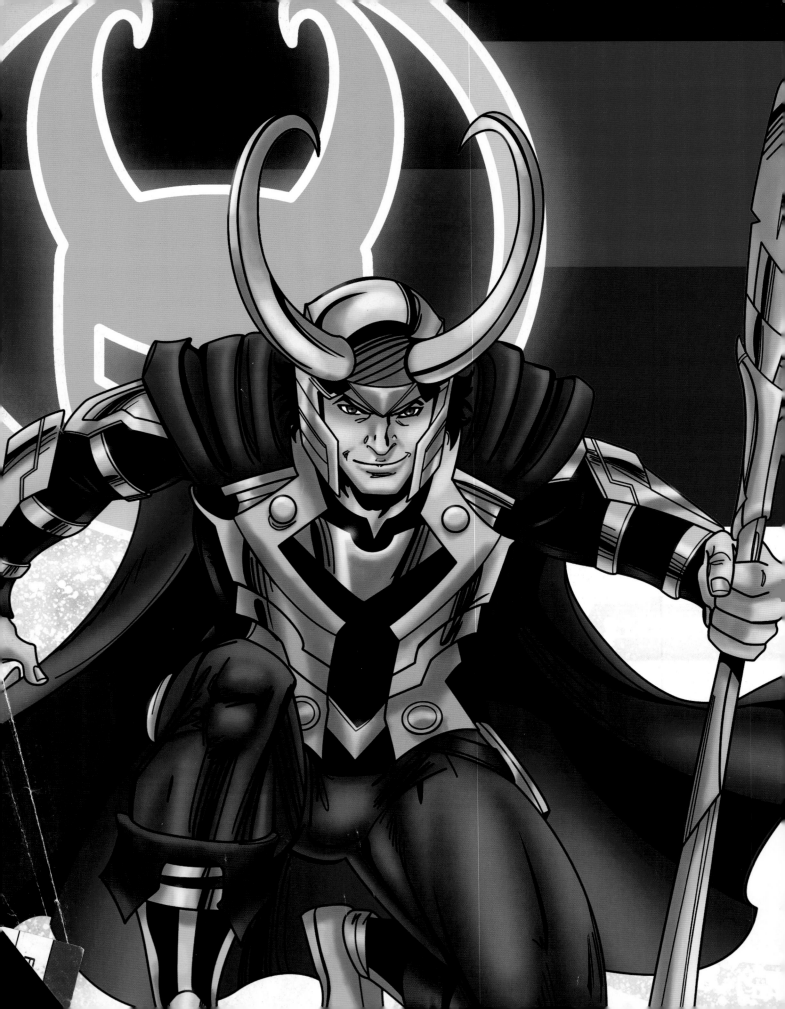

LOKI

BIO:

Perhaps the most powerful sorcerer in all of Asgard, Loki was adopted by Odin and grew up alongside Thor. As he came of age, Loki became a formidable foe to Thor and the rest of the Avengers.

REAL NAME:
Loki Laufeyson

HEIGHT:
6'4"

WEIGHT:
525 lbs.

POWERS & ABILITIES:

• Has increased lifespan and superhuman strength, and is immune to terrestrial diseases and resistant to conventional injury

• Can shape-shift, gaining the basic natural abilities inherent in each form

• Is capable of astral projection, molecular rearrangement, eldritch energy blasts, illusion casting, flight via levitation, telepathy, hypnosis, and teleportation

• Can mystically imbue objects or beings with specific but temporary powers, and enhance the powers of superhumans

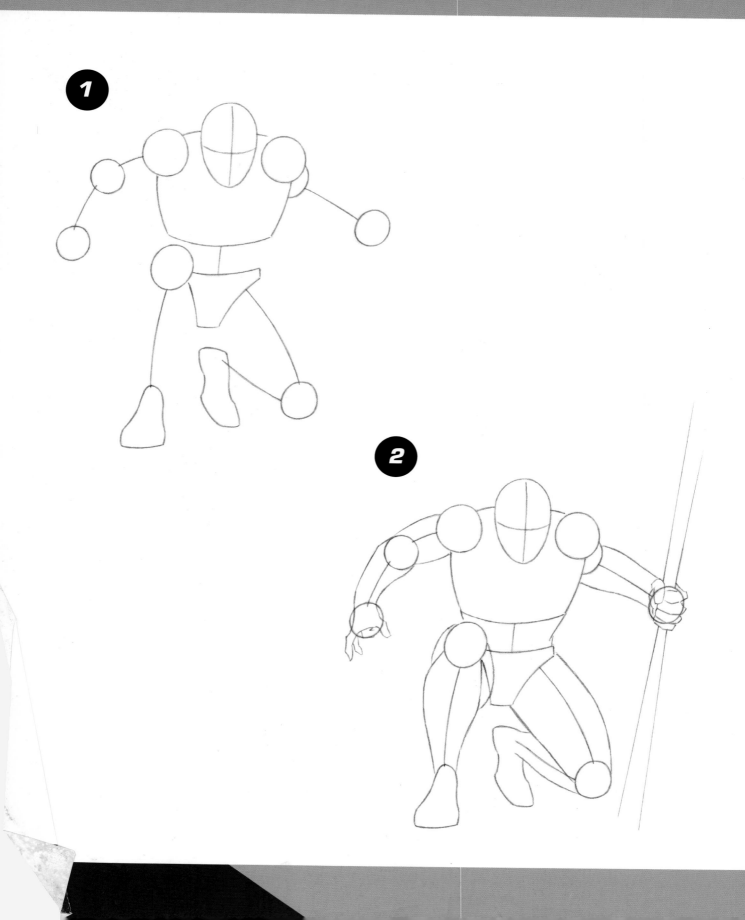

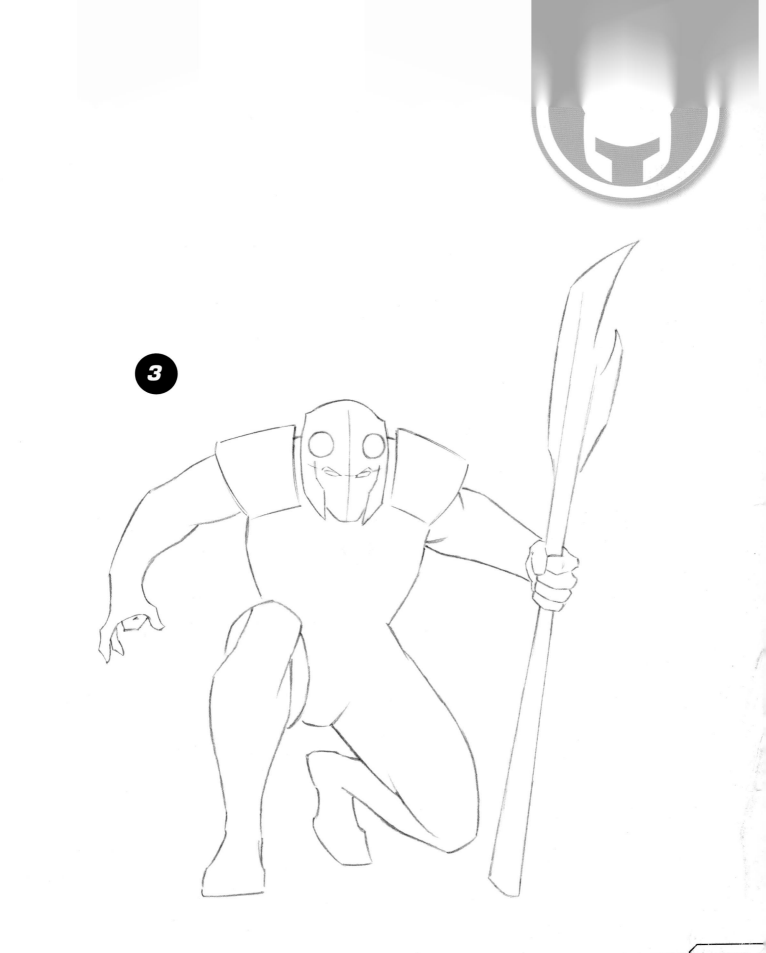

3

Loki's mystical sceptre enhances his powers of reality manipulation,
including shape-shifting, mind control, and illusion-casting.

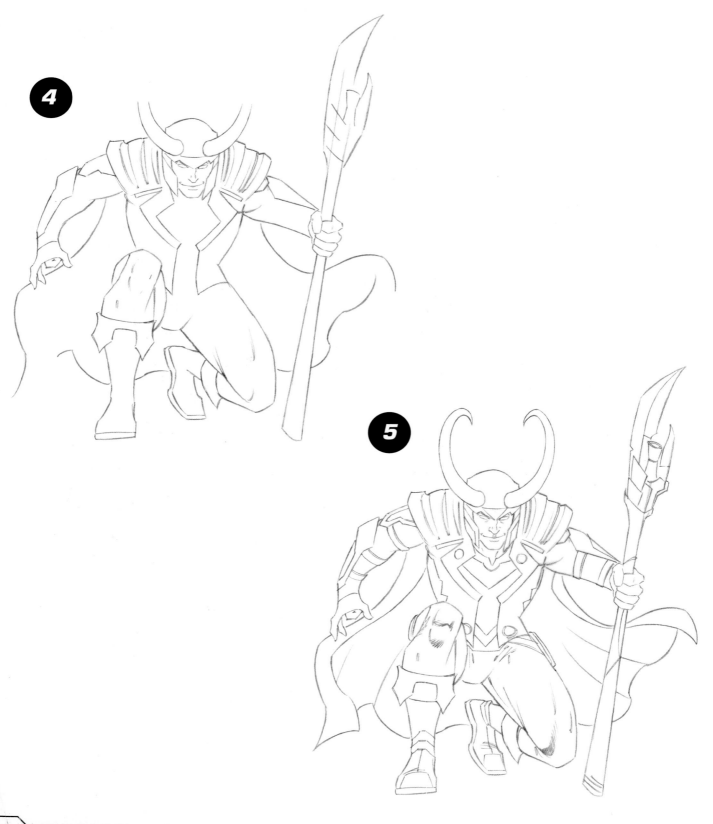

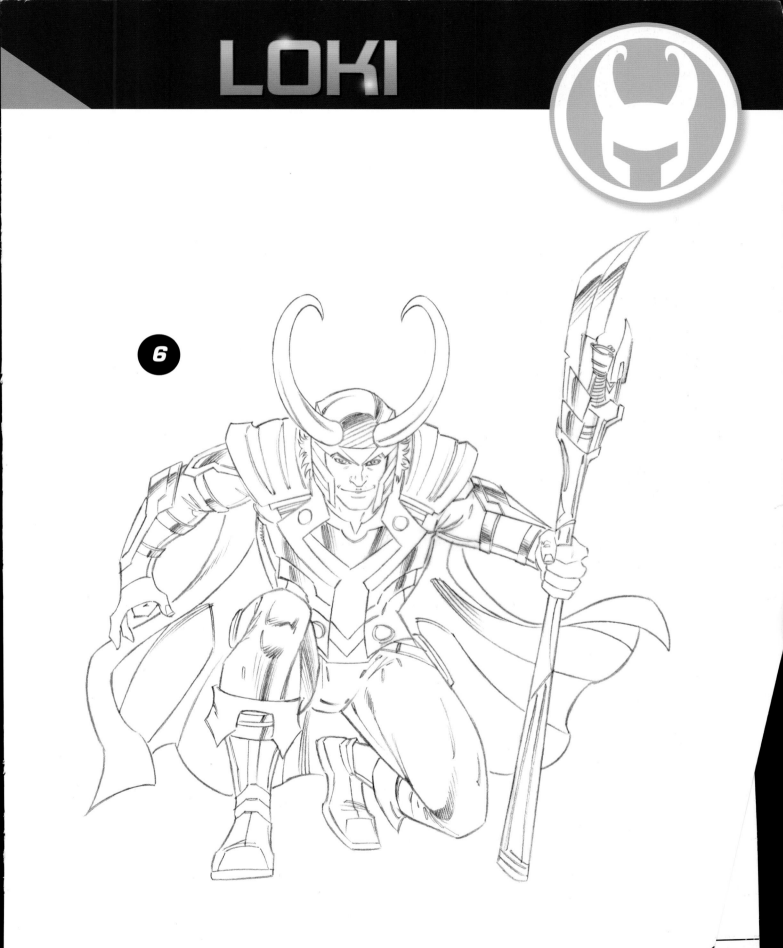

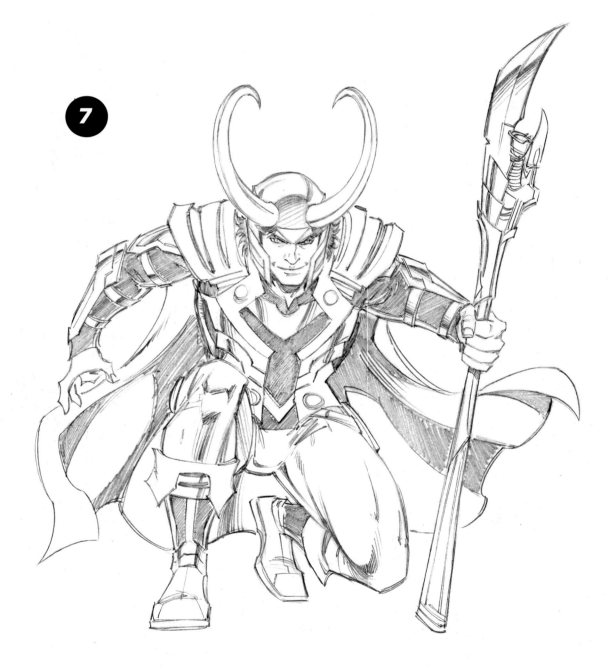

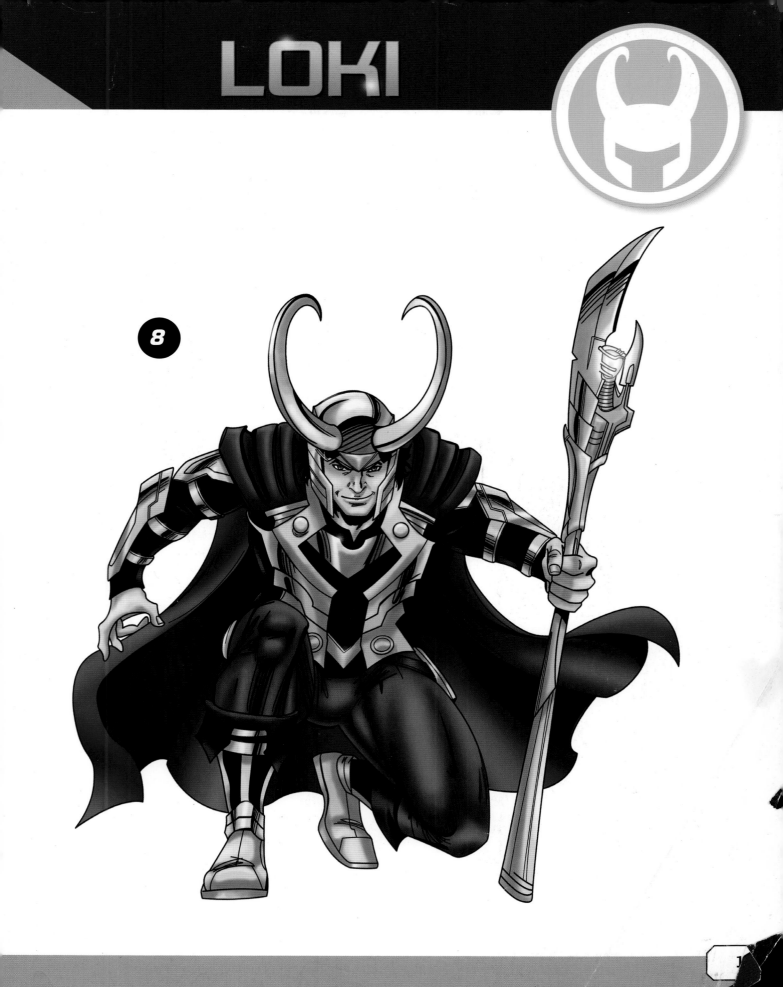

THE END